Dialogues with
Marcel Duchamp

THE DOCUMENTS OF 20TH-CENTURY ART

ROBERT MOTHERWELL,
GENERAL EDITOR

BERNARD KARPEL,
DOCUMENTARY EDITOR

ARTHUR A. COHEN,
MANAGING EDITOR

Dialogues with Marcel Duchamp

By Pierre Cabanne

TRANSLATED FROM THE FRENCH
BY RON PADGETT

NEW YORK THE VIKING PRESS

Entretiens Avec Marcel Duchamp © *Editions Pierre Belfond 1967*
English language translation Copyright © 1971 by Thames and
Hudson Ltd.
All rights reserved
Published in 1971 in a hardbound and paperback edition by
The Viking Press, Inc., 625 Madison Avenue, New York, N.Y. 10022
Published simultaneously in Canada by
The Macmillan Company of Canada Limited

SBN *670–27207–8 (hardbound)*
 670–01913–5 (paperback)

Library of Congress catalog card number: 77–83255

Printed and bound in Great Britain
by Cox and Wyman Ltd., London, Fakenham and Reading

Marcel Duchamp [1887–1968], *An appreciation by Jasper Johns,*
was first published in Artforum *in November 1968.*

Series designed by Samuel N. Antupit

Cover photograph: Portrait of Marcel Duchamp by Irving Penn, 1948.
Copyright 1960 by Irving Penn; courtesy The Condé Nast
Publications, Inc.

Third printing May 1976

Contents

Introduction by Robert Motherwell

In the original French edition of this book, Pierre Cabanne wrote, shortly before Duchamp's death: "These interviews with Marcel Duchamp took place in his studio at Neuilly [near Paris], where he and his wife live during the six months they spend in France each year. It is the first time that the most fascinating and the most disconcerting inventor in contemporary art has agreed to talk about and explain, so profoundly and at such length, his actions, his reactions, his feelings, and the choices he made." He adds that Duchamp gave these interviews with a "serenity from which he never departed, and which gave his theorems an undeniable grandeur; one divined a man not only detached, but 'preserved.' Through his creative acts, Marcel Duchamp did not want to impose a new revolutionary language, but to propose an attitude of mind; this is why these interviews constitute an astonishing moral lesson. . . . He speaks in a calm, steady, level voice; his memory is prodigious, the words that he employs are not automatic or stale, as though one is replying for the nth time to an interviewer, but carefully considered; it must not be forgotten that he wrote 'Conditions of a Language: Research into *First Words*.' Only one question provoked in him a marked reaction: near the end, when I asked him whether he believed in God. Notice that he very frequently utilizes the word 'thing' to designate his own creations, and 'to make' to evoke his creative acts. The terms 'game,' or 'it is amusing,' or 'I wanted to amuse myself,' recur often; they are ironic evidence of his nonactivity.

"Marcel Duchamp always wore a pink shirt, with fine green stripes; he smoked Havana cigars incessantly (about ten a day); went out little; saw few friends; and went neither to exhibitions nor to museums. . . ."

The present translation into English contains the entire text of the interviews, but differs in several respects from the French edition. The latter was not illustrated, and while Duchamp's work is not illustrated here (since there are several books containing illustrations of most of his work[1]), *he* is. When he was asked if he would like to write a preface to this English-language edition, he replied that he would not but would like his friend and summer neighbor in Cadaqués, Spain, Salvador Dali, to do so. Dali's preface appears here for the first time; so does a much more detailed chronology than in the French edition, and a more authoritative selected bibliography, by Bernard Karpel, Librarian of The Museum of Modern Art, New York.

(Pierre Cabanne, who was born in 1921, has been for some years art critic of the Paris review *Arts-Loisirs*. He has written books on van Gogh, the Cubist epoch, Degas, and Picasso, and he contributes to many French and foreign art magazines.)

Marcel Duchamp's own numerous writings (in the original French or in English) were published as "*Marchand du Sel: Écrits de Marcel Duchamp*," in 1958.[2]

Duchamp died suddenly in his studio at Neuilly on October 1, 1968, at the age of eighty-one, a year and a half after the original French publication of these conversations.

———

These conversations are more than mere interviews. They are Marcel Duchamp's "summing up," and constitute as vivid a self-portrait as we possess of a major twentieth-century artist, thanks to Duchamp's intelligence, scrupulousness, and disdain for the petty. Here, as throughout his life, he has rejected, as much as one can, that game of rivalry which makes so many modern artists uneasy and angry, or bitter, and sometimes false to themselves and to historical truth. In these pages, Duchamp's effort to be "objective" is sustained with an intellectual strength and modesty (though he had his own arrogance) of which few celebrated artists approaching their eighties are capable. We are also

[1] Notably in Robert Lebel (1959; later edition without color); Calvin Tomkins (1966); and Arturo Schwarz (1969); see Bibliography, nos. 37, 50, 76.

[2] Edited by the great Dada authority Michel Sanouillet; see Bibliography, no. 6.

fortunate in Pierre Cabanne's intelligent choice of questions[3] and his sheer tenacity as Duchamp's questioner (he is obviously familiar with Duchamp's remark, "There is no solution because there is no problem"). Cabanne intuitively knows when not to press too hard, and when to come back discreetly again and again to a dropped question, finally to receive the "answer." On rereading these conversations, Duchamp said to Cabanne (in effect) that "this is from the horse's mouth." I, for one, shall always be grateful to Duchamp for his willingness to be so intensively recorded, just before he died.

I knew Duchamp casually, beginning in the early 1940s, in New York City, in the French Surrealist milieu. Later in the decade, we used to meet when I was working on vexing questions that arose while I was editing my Dada anthology.[4] We met once or twice at the dusty New York studio that he had for years (on West Fourteenth Street, I think), but more often at a little downstairs Italian restaurant, where he invariably ordered a small plate of plain spaghetti with a pat of butter and grated Parmesan cheese over it, a small glass of red wine, and espresso afterward. In those days his lunch must have cost seventy-five cents, or less.[5] He could not have been more pleasant, more open, more generous, or more "objective," especially when I recall how few of my questions had to do with him.[6] Most of my questions had to do with the clarification of various Dada mysteries (such as conflicting stories about the discovery of the name "Dada") that had become clouded in legend so many years after the fact, often deliberately. Later, I enlisted his aid (which ultimately proved fruitless) in trying to reconcile Richard Huelsenbeck and Tristan Tzara to having their recent writings appear together between the same covers. They detested each other, rivals long after the Dada period.

[3] He obviously followed with care Robert Lebel's *Sur Marcel Duchamp* (Paris: Trianon Press, 1959), design and layout by Marcel Duchamp and Arnold Fawcus. The English translation by George Heard Hamilton was published under the title *Marcel Duchamp* (New York: Grove Press, 1959). The American edition also contains André Breton's beautiful and difficult tribute, Henri-Pierre Roché's impressions, and a brief lecture, "The Creative Act," that Duchamp gave before .he American Federation of Arts, in Houston, Texas, in April, 1957. (See Bibliography, no. 37.)

[4] *The Dada Painters and Poets* (See Bibliography, no. 40).

[5] Lebel also remarks on the frugality of his eating habits.

[6] I also received his approval for a translation of his "Green Box" to appear in the Documents of Modern Art series, which it did, finally, more than a decade later: "The Bride Stripped Bare by Her Bachelors, Even," a typographic version by Richard Hamilton of Marcel Duchamp's "Green Box," translated by George Heard Hamilton. (See Bibliography, no. 3). Both brief essays by the two Hamiltons in this volume are excellent, as are the layout and the translation, approved by Duchamp himself.

I had asked Duchamp to act as a mediator in regard to the book because of the *sense* one already had of him, seeing him among the Parisian Surrealists gathered in New York City during the Second World War. The Surrealists were the closest-knit group of artists, over the longest period of time, that I know of, with all the unavoidable frictions as well as the camaraderie implied by such intimacy. Often their various group projects produced violent disagreements. But their respect for Duchamp—who was not a Surrealist, but as he himself said, "borrowed" from the world—and, above all, for his fairness as a mediator, was great.[7] It seemed to me that he gave a certain emotional stability to that group in exile during those anxiety-ridden years after the defeat of France in 1940, when the Nazis gained everywhere, for a time.

I remember once at a Surrealist gathering watching André Breton and Max Ernst standing mouth-to-mouth, in that curious French fashion, arguing with rage about something I do not remember—a personal matter, I think, but one which also raised the question of their professional indebtedness toward each other. At such moments as these, only Duchamp, with his detachment, his fairness (which, of course, is not the same thing), and his innate sensitivity, could try to bring calm.

It was with these same qualities that he tried to help me edit my Dada anthology, in the later 1940s.[8] Over the years, he himself was co-editor of a surprising number of projects, and heaven knows how many people he helped, or in how many ways. One should keep this in mind when Duchamp tells Cabanne he doesn't do much during the day, or when he so often gives his reason for having done something as that it "amused" him. It *is* true that he could not stand boredom. He rarely attended large gatherings, and when he did it was barely long enough to take off his hat.

─────────

An artist must be unusually intelligent in order to grasp simultaneously many structured relations. In fact, intelligence can be considered as the *capacity* to grasp complex relations; in this sense, Leonardo's intelligence, for instance, is almost beyond belief. Duchamp's

─────────

[7] On the poster of the 1938 Paris Surrealist Exhibition, Duchamp is listed among the organizers as "General Mediator."

[8] I also spoke to him a bit about his distaste for the technical procedures involved in becoming an American citizen. When I asked him why he preferred to live here, he repeated several times that being in France was like being in a net full of lobsters clawing each other. But his heart remained there, I think—though in the U.S.A. he was better known, and at the same time allowed privacy and noncommitment to anything that did not interest him (as he says in this book).

intelligence contributed many things, of course, but for me its greatest accomplishment was to take him beyond the merely "aesthetic"[9] concerns that face every "modern" artist—whose role is neither religious nor communal, but instead secular and individual. This problem has been called "the despair of the aesthetic:" if all colors or nudes are equally pleasing to the eye, why does the artist choose one color or figure rather than another? If he does not make a purely "aesthetic" choice, he must look for further criteria on which to base his value judgements. Kierkegaard held that artistic criteria were first the realm of the aesthetic, then the ethical, then the realm of the holy. Duchamp, as a nonbeliever, could not have accepted holiness as a criterion but, in setting up for himself complex technical problems or new ways of expressing erotic subject matter, for instance, he did find an ethic beyond the "aesthetic" for his ultimate choices.[10] And his most successful works, paradoxically, take on that indirect beauty achieved only by those artists who have been concerned with more than the merely sensuous. In this way, Duchamp's intelligence accomplished nearly everything possible within the reach of a modern artist, earning him the unlimited and fully justified respect of successive small groups of admirers throughout his life. But, as he often says in the following pages, it is posterity who will judge, and he, like Stendhal, had more faith in posterity than in his contemporaries. At the same time, one learns from his conversations of an extraordinary artistic adventure, filled with direction, discipline, and disdain for art as a trade and for the repetition of what has already been done.[11]

There is one "deception" of Duchamp's here, however, in the form of a deliberate omission. He never mentions, even when questioned about his having given up art, that for twenty years (1946–1966) he had been constructing a major work: "Given: 1. the waterfall, 2. illuminating gas."[12] This last work of his is an environmental room, secretly

[9] "Aesthetic" in this context refers to the perception of the world's surface through the senses, primarily sight; felt visual discrimination (what Duchamp called "retinal").

[10] "To get away from the physical aspect of painting ... I was interested in ideas, not merely visual products. I wanted to put painting once again at the service of the mind." [1945] "The final product ["Large Glass"] was to be a wedding of mental and visual relations." [1959]

[11] Duchamp often said in conversation that no book should be more than fifty pages long, that a skilled writer could say everything he had to say in that space. Though he seemed not to be a great reader, I suspected that he had read Paul Valéry's discourse on the method of Leonardo da Vinci; but when I suggested this once, he displayed a certain ambivalence and evasiveness, not unlike Valéry's own towards Dada—at least, this was my impression.

[12] *Étant Donnés: 1e la chute d'eau, 2e le gaz d'éclairage.*

"made," with some assistance from his wife, Teeny, in a studio on West Eleventh Street in New York. It is now in the Philadelphia Museum in a gallery adjacent to the Arensberg Collection, as Duchamp had apparently intended.[13] When its existence became known after his death, it was realized how literal Duchamp had been in insisting that the artist should go "underground." In spite of all appearances, Duchamp had never ceased to work; moreover, he managed to keep his privacy inviolate in New York City—in a way that he thought would have been impossible for him in Paris. This extraordinary achievement, in addition to its place in Duchamp's *oeuvre* as a completely new work, exemplifies another aspect of the artist's character. I mean a theatricality and a brutality of effect wholly remote from the intellectualism and refinement of the earlier work. For, despite Duchamp's urbanity, from another standpoint, Duchamp was the great *saboteur*, the relentless enemy of painterly painting (read Picasso and Matisse), the asp in the basket of fruit. His disdain for sensual painting was as intense as was his interest in erotic machines. Not to see this is not to take his testament seriously. No wonder he smiled at "art history," while making sure his work ended up in museums. Picasso, in questioning himself about what art is, immediately thought, "What is not?" (1930s). Picasso, as a painter, wanted boundaries. Duchamp, as an anti-painter, did not. From the standpoint of each, the other was involved in a *game*. Taking one side or the other is the history of art since 1914, since the First World War.

—ROBERT MOTHERWELL

[13] There is a superb essay, illustrated, by Anne d'Harnoncourt and Walter Hopps on the new work in the *Bulletin* of the Philadelphia Museum (June 25, 1969). See also the July-August 1969 issue of *Art in America*.

Preface by Salvador Dali

L'échecs, c'est moi
("Chess, it's me.")

The first man to compare the cheeks of a young woman to a rose was obviously a poet; the first to repeat it was possibly an idiot. The ideas of Dada and Surrealism are currently in the process of being repeated monotonously: soft watches have produced innumerable soft objects. And "readymades" cover the globe! The loaf of bread fifteen yards long has become a loaf of fifteen miles! A monstrous, current specialization is the attraction to certain Happenings which Dadaists or Surrealists themselves would have had neither the time nor the desire to produce. . . .

LA ROSE ET LES JOUES (THE ROSE AND CHEEKS)

It is already forgotten that, during the Dada period, the then leader, Tristan Tzara, in a manifesto proclaimed:

Dada is this; Dada is that; Dada is this;
Dada is that; Dada is nevertheless shit.

This type of humor, more or less black, is lacking in the newest generation, who believe, in good faith, that their neo-Dadaism is more sublime than the art of Praxiteles!

DADA ET LE MERDE (DADA AND SHIT)

Marcel Duchamp spoke to me, during the course of the Second World War (traveling between Arcachon and Bordeaux), of a new interest in the preparation of shit, of which the small excretions from

ÉCHEC ET ÉCHECS

PAGE 13

("CHECK"
AND CHESS)

the navel are the "de luxe" editions. To this I replied that I wished to have genuine shit, from the navel of Raphael. Today a well-known Pop artist of Verona sells artists' shit (in very sophisticated packaging) as a luxury item!

===

*BRULÉ,
BROYÉ,*
(ROASTED,
GROUND)

When Duchamp understood that he had generously sown the wind with his youthful ideas until he had no more, he aristocratically stopped his "game" and announced prophetically that other young men would specialize in the chess of contemporary art.

Then he played chess itself.

===

The "Chocolate Grinder"[1] by Marcel Duchamp is sublime when one knows that it was in Rouen that he found it. It *is* necessary to know that the Municipal Museum of Art in Rouen owns "*Les énervées de Jumièges,*"[2] and that Joan of Arc was roasted at Rouen.

===

(17 AND 17
MILLION)

In Paris, in the early days, there were 17 persons who understood the "readymades"—the very rare readymades by Marcel Duchamp. Nowadays there are 17 million who understand them, and that one day, when all objects that exist are considered readymades, there will be no readymades at all. Then Originality will become the artistic Work, produced convulsively by the artist *by hand.*

===

*LE ROI ET
LE ROI*
(THE KING
AND THE
KING)

Marcel Duchamp could have been a king if, instead of making the "Chocolate Grinder," he had made the "Holy Ampulla," the unique, divine readymade, to anoint himself as king. Duchamp then could have been crowned at Rheims. And Dali would have asked his permission to paint a picture of the "King and Queen Traversed by Nudes at High Speed."

—Salvador Dali
New York City
January 1968
(*Translated by Albert Field*)

[1] In France, many pastry shops serve ground hot chocolate. Their signs are often of colored glass, hanging in the window. [Ed.]

[2] A picture of two young princes adrift in a boat with their tendons cut by the king, their father. [Ed.]

Eight Years of Swimming Lessons

PIERRE CABANNE: Marcel Duchamp, it is now 1966; in a few months you'll be eighty years old. In 1915, over half a century ago, you left for the United States. Looking back over your whole life, what satisfies you most?

MARCEL DUCHAMP: First, having been lucky. Because basically I've never worked for a living. I consider working for a living slightly imbecilic from an economic point of view. I hope that some day we'll be able to live without being obliged to work. Thanks to my luck, I was able to manage without getting wet. I understood, at a certain moment, that it wasn't necessary to encumber one's life with too much weight, with too many things to do, with what is called a wife, children, a country house, an automobile. And I understood this, fortunately, rather early. This allowed me to live for a long time as a bachelor, more easily than if I had had to face the normal difficulties of life. Fundamentally, this is the main thing. So I consider myself very happy. I've never had a serious illness, or melancholy or neurasthenia. Also, I haven't known the strain of producing, painting not having been an outlet for me, or having a pressing need to express myself. I've never had that kind of need—to draw morning, noon, and night, to make sketches, etc. I can't tell you any more. I have no regrets.

CABANNE: And your greatest regret?

DUCHAMP: I don't have any, I really don't. I've missed nothing. I have had even more luck at the end of my life than at the beginning.

CABANNE: André Breton said that you were the most intelligent man of the twentieth century. To you, what is intelligence?

DUCHAMP: That's exactly what I was going to ask you! The word "intelligence" is the most elastic one can invent. There is a logical or Cartesian form of intelligence, but I think Breton meant to say something else. He envisaged, from the Surrealist point of view, a freer form of the problem; for him, intelligence was in some way the penetration of what the average normal man finds incomprehensible or difficult to understand. There is something like an explosion in the meaning of certain words: they have a greater value than their meaning in the dictionary.

Breton and I are men of the same order—we share a community of vision, which is why I think I understand his idea of intelligence: enlarged, drawn out, extended, inflated if you wish. . . .

CABANNE: In the sense that you yourself have enlarged, inflated, and exploded the limits of creation, according to your own "intelligence."

DUCHAMP: Perhaps. But I shy away from the word "creation." In the ordinary, social meaning of the word—well, it's very nice but, fundamentally, I don't believe in the creative function of the artist. He's a man like any other. It's his job to do certain things, but the businessman does certain things also, you understand? On the other hand, the word "art" interests me very much. If it comes from Sanskrit, as I've heard, it signifies "making." Now everyone makes something, and those who make things on a canvas, with a frame, they're called artists. Formerly, they were called craftsmen, a term I prefer. We're all craftsmen, in civilian or military or artistic life. When Rubens, or someone else, needed blue, he had to ask his guild for so many grams, and they discussed the question, to find out if he could have fifty or sixty grams, or more.

It was really craftsmen like that who appear in the old contracts. The word "artist" was invented when the painter became an individual, first in monarchical society, and then in contemporary society, where he is a gentleman. He doesn't make things for people; it's the people who come to choose things from among his production. The artist's revenge is that he is much less subject to concessions than before, under the monarchy.

CABANNE: Breton not only said that you are one of the most intelligent men of the twentieth century, but, and I quote, "for many, the most irritating."

DUCHAMP: I suppose he means that not following the style of the time bothers many people, who see this as an opposition to what they're doing, a rivalry if you wish but one which in reality doesn't exist at all.

That rivalry existed only for Breton and the Surrealists, because they figured that one could do something other than what was being done at that point.

CABANNE: Do you think you've disturbed a lot of people?

DUCHAMP: No, not about this, because I've had anything but a public life. What little public life I did have was in Breton's group, and with others who were interested in my work a bit. In the true sense of the word, I've never had a public life, since I never exhibited the "Glass." It stayed in storage all the time.

CABANNE: So it's your moral position, more than your work, which was irritating?

DUCHAMP: There again, I had no position. I've been a little like Gertrude Stein. To a certain group, she was considered an interesting writer, with very original things. . . .

CABANNE: I admit I never would have thought of comparing you with Gertrude Stein. . . .

DUCHAMP: It's a form of comparison between people of that period. By that, I mean that there are people in every period who aren't "in." No one's bothered by it. Whether I had been in or not, it would have been all the same. It's only now, forty years later, that we discover things had happened forty years before that might have bothered some people— but they couldn't have cared less then!

CABANNE: Before going into details, we could tackle the key event in your life, that is, the fact that, after about twenty-five years of painting, you abruptly abandoned it. I'd like you to explain this rupture.

DUCHAMP: It came from several things. First, rubbing elbows with artists, the fact that one lives with artists, that one talks with artists, displeased me a lot. There was an incident, in 1912, which "gave me a turn," so to speak; when I brought the "Nude Descending a Staircase" to the Indépendants, and they asked me to withdraw it before the opening. In the most advanced group of the period, certain people had extra-ordinary qualms, a sort of fear! People like Gleizes, who were, never-theless, extremely intelligent, found that this "Nude" wasn't in the line that they had predicted. Cubism had lasted two or three years, and they already had an absolutely clear, dogmatic line on it, foreseeing every-thing that might happen. I found that naïvely foolish. So, that cooled me off so much that, as a reaction against such behavior coming from artists whom I had believed to be free, I got a job. I became a librarian at the Sainte-Geneviève Library in Paris.

I made this gesture to rid myself of a certain milieu, a certain attitude, to have a clean conscience, but also to make a living. I was twenty-five.

I had been told that one must make a living, and I believed it. Then the war came, which upset everything, and I left for the United States.

I kept working on the "Large Glass" for eight years, working on other things in the meantime. I had already abandoned stretchers and canvas. I already had a sort of disgust for them, not because there were too many paintings or stretched canvases, but because, in my eyes, this wasn't necessarily a way of expressing myself. The "Glass" saved me, by virtue of its transparency.

When you make a painting, even abstract, there is always a sort of necessary filling-in. I wondered why. I always asked myself "why" a lot, and from that questioning came doubt, doubt of everything. I came to doubt so much that in 1923 I said, "Good, that's going well." I didn't abandon everything at a moment's notice, on the contrary. I returned to France from America, leaving the "Large Glass" unfinished. When I returned, a lot of things had happened. I was married in, I think, 1927; my life was looking up. I had worked eight years on this thing, which was willed, voluntarily established according to exact plan, but despite that, I didn't want it—and this is perhaps why I worked such a long time—to be the expression of a sort of inner life. Unfortunately, with time I had lost my fire in regard to its execution; it no longer interested me, no longer concerned me. So I had had enough of it, and I stopped, but with no abrupt decision; I didn't even think about it.

CABANNE: It was like a sort of progressive refusal of traditional means.

DUCHAMP: That's it.

CABANNE: I noted something: first, which isn't new, your passion for chess . . .

DUCHAMP: It's not a serious matter, but it does exist.

CABANNE: But I also noted that this passion was especially great when you weren't painting.

DUCHAMP: That's true.

CABANNE: So, I wondered whether, during those periods, the gestures directing the movements of pawns in space didn't give rise to imaginary creations—yes, I know, you don't like that word—creations which, in your eyes, had as much value as the real creation of your pictures and, further, established a new plastic function in space.

DUCHAMP: In a certain sense, yes. A game of chess is a visual and plastic thing, and if it isn't geometric in the static sense of the word, it is mechanical, since it moves; it's a drawing, it's a mechanical reality. The pieces aren't pretty in themselves, any more than is the form of the game, but what is pretty—if the word "pretty" can be used—is the

movement. Well, it is mechanical, the way, for example, a Calder is mechanical. In chess there are some extremely beautiful things in the domain of movement, but not in the visual domain. It's the imagining of the movement or of the gesture that makes the beauty, in this case. It's completely in one's gray matter.

CABANNE: In short, there is in chess a gratuitous play of forms, as opposed to the play of functional forms on the canvas.

DUCHAMP: Yes. Completely. Although chess play is not so gratuitous; there is choice. . . .

CABANNE: But no intended purpose?

DUCHAMP: No. There is no social purpose. That above all is important.

CABANNE: Chess is the ideal work of art?

DUCHAMP: That could be. Also, the milieu of chess players is far more sympathetic than that of artists. These people are completely cloudy, completely blind, wearing blinkers. Madmen of a certain quality, the way the artist is supposed to be, and isn't, in general. That's probably what interested me the most. I was highly attracted to chess for forty or forty-five years, then little by little my enthusiasm lessened.

CABANNE: Now, we must go back to your childhood. You were born July 28, 1887, in Blainville, in the Seine-Maritime district. Your father was a notary. At home, the evenings were spent playing chess or music. You were the third of seven children, six of whom survived: the three boys, Gaston, the oldest, who became Jacques Villon; Raymond, who became the sculptor Duchamp-Villon; Marcel, yourself; then the three sisters, Suzanne, Yvonne, and Magdeleine. These births were spaced out in a surprising regularity, 1875–1876, 1887–1889, 1895–1898. From a good, middle-class Norman background, you grew up in a very provincial, Flaubertian atmosphere.

DUCHAMP: Completely. Very near Ry, the town where Madame Bovary took the coach for Yvetot, I believe. It's very Flaubertian indeed. But obviously one knows that only afterward, when one reads *Madame Bovary*, at sixteen.

CABANNE: I believe your first important artistic adventure, which took place in 1905, was a course in printing in Rouen. It gave you a genuine printer's competence.

DUCHAMP: That's a funny episode. Expecting to serve, under the law, two years of military service, I felt, being neither militaristic nor soldierly, that I must still try to profit from the "three-year law"; that is, do only one year by signing up immediately. So I went through the steps necessary to find out what one could do without being a lawyer or doctor, since these were the two usual exemptions. That's how I

learned that there was an examination for "art workers," which allowed one year's service instead of three, under the same conditions as those of a lawyer or doctor. Then I wondered what kind of art worker I might be. I discovered that one could be a typographer or a printer of engravings, of etchings. That's what they meant by art worker. I had a grandfather who had been an experienced engraver; our family had saved some of his copperplates, on which he had engraved really extraordinary views of old Rouen. So I worked at a printer's, and I asked him to teach me how to print these plates. He agreed. I worked with him, and passed the examination, in Rouen. The jury was composed of master craftsmen, who asked me a few things about Leonardo da Vinci. As the written part, so to speak, you had to show what you could do by way of printing engravings. I had printed my grandfather's plate, and offered a proof to each member of the jury. They were enchanted. They gave me 49, out of a possible grade of 50. So I was exempted from two years in the service and assigned to a group of student officers. At the end of my year, in Eu, the captain in charge of those exempted questioned each soldier as to what he did in civilian life. When he learned that I was an "art worker," he said nothing; but I understood that, for him, the corps of French officers could not have a worker earning seven francs a day in its ranks, and I had the impression that I wouldn't go very far as a soldier.

CABANNE: Your military career was nipped in the bud!

DUCHAMP: Absolutely. That was fine, however. Then I was discharged. So I became completely exempt from further military service.

CABANNE: Your first known canvas dates from 1902, when you were fifteen. It's "The Church in Blainville," your native village. How did you discover painting? Did your family encourage you?

DUCHAMP: The house we lived in was filled with the memory of my grandfather, who had produced engravings galore of the countryside. Further, I was twelve years younger than Jacques Villon, and eleven younger than Raymond Duchamp-Villon, who had been artists for a long time, especially Villon. I already had the opportunity to think about it. No objection from my father, who, with his two other sons, was used to dealing with these questions. So, for me there was no difficulty. My father even agreed to help me financially.

CABANNE: I believe your mother was an artist also. Didn't she paint still lifes?

DUCHAMP: She wanted to cook them too, but in all her seventy years she never got around to it. She did Strasbourgs on paper. It never went any further.

CABANNE: So in your family there was an atmosphere of artistic under-standing?

DUCHAMP: Very clearly, yes. There were no difficulties about that.

CABANNE: The person nearest to you was your sister Suzanne?

DUCHAMP: Yes. She too was somewhat "in on it," since she painted all her life—a little less, but with a lot more perseverance and a lot more enthusiasm than me.

CABANNE: Wasn't she your favorite model?

DUCHAMP: Yes, but I had two other sisters, who came afterward. All of them put up with modeling; one after the other, it was easier.

CABANNE: After your year of military service, you left for Paris, where you enrolled at the Académie Jullian. You had already spent a year there with Villon, who, at that time, was doing cartoons for the newspapers; you too tried this. Do you remember the "masters" you studied with at Jullian?

DUCHAMP: Absolutely not. Obviously the great man was Jules Lefebre, but I don't remember if he was teaching when I was there. There was another teacher, younger, but I don't remember his name at all. Besides, I only spent one year at Jullian. What did I do? I played billiards in the morning, instead of going to the studio! Nevertheless, I once tried entering the École des Beaux-Arts competition, which was a "flop" as you say in English. The first test was to do a nude in charcoal—I flunked.

CABANNE: And so you joined the innumerable flunks of the École des Beaux-Arts.

DUCHAMP: Absolutely, and I'm proud of it now. Back then, obviously, I had the innocent enthusiasm of one who wants to "make beaux-arts." Then I resumed cartooning and the art sessions at Jullian. I got ten francs for a quarter page in *Le Sourire* and *Le Courrier français*, which was going great guns at the time. Villon got me in. You know, the director was a very odd man, Jules Roques. Villon used to go to the newspaper Monday morning to trap him when he arrived at his office, to force four sous out of him, because evidently he never used to pay.

CABANNE: Well, to summarize your beginnings: a middle-class family, a very prudent and very conventional artistic education. Wasn't the antiartistic attitude you took later a reaction, even a revenge, against these things?

DUCHAMP: Yes, but I wasn't sure of myself, especially in the beginning. . . . When you're a kid, you don't think philosophically; you don't say, "Am I right? Am I wrong?" You simply follow a line that amuses you

more than another, without thinking very much about the validity of what you're doing. It's later when you ask yourself if you're right or wrong, and if you should change. Between 1906 and 1910 or 1911, I sort of drifted between different ideas: Fauve, Cubist, returning sometimes to things slightly more classical. An important event for me was the discovery of Matisse, in 1906 or 1907.

CABANNE: And not Cézanne?

DUCHAMP: No, not Cézanne.

CABANNE: With Villon, you associated with a group of artists your own age, that is, about twenty to twenty-five years old. You certainly must have talked about Cézanne, Gauguin, Van Gogh?

DUCHAMP: No. The conversation centered above all on Manet. The great man that he was. Not even on the Impressionists. Seurat was completely ignored; one barely knew his name. Remember that I wasn't living among painters, but rather among cartoonists. In Montmartre, where I was living, rue Caulaincourt, next door to Villon, we associated with Willette, Léandre, Abel Faivre, Georges Huard, etc.—this was completely different; I wasn't in contact with the painters at that time. Even Juan Gris, whom I knew a little later, was doing illustrations. We used to go together to a magazine headed by the poster designer Paul Iribe, who had started it. We played billiards together in a café in the rue Caulaincourt. We gave each other tips. And we were never paid. At twenty francs per page.

CABANNE: That wasn't bad, provided you could get hold of them!

DUCHAMP: At that time I knew Gris slightly, but I left Montmartre in 1908.

CABANNE: To go live in Neuilly?

DUCHAMP: Yes, until 1913. A couple of steps from where I live now.

CABANNE: In the 1905 Salon d'Automne, there was the famous "cage aux fauves,"[1] and, at the same time, a Manet-Ingres retrospective. I suppose these two interested you especially.

DUCHAMP: Obviously. Manet's name came up in every conversation on painting. Cézanne, then, was for many people just a flash in the pan. . . . I'm talking about the people I knew, of course; among painters it must have been otherwise. . . . But anyway it was at the Salon d'Automne of 1905 that the idea of being able to paint came to me. . . .

CABANNE: You were already painting. . . .

DUCHAMP: Yes, but like that . . . At that time I was especially interested in drawing. Around 1902–1903, I had done some pseudo-Impressionist things, misdirected Impressionism. In Rouen I had a friend, Pierre

[1] "Fauve Cage," literally, "wild-animal cage." [Ed.]

Dumont, who was doing the same thing, but more exaggerated. . . . Then I turned toward Fauvism.

CABANNE: A particularly intense Fauvism. At the Philadelphia Museum, thanks to the Arensberg collection, which we'll talk about again, your Fauve canvases are striking in their vehemence. One of your biographers, Robert Lebel, compares their acid stridence to that of Van Dongen, and also to German Expressionism.

DUCHAMP: I really don't recall how it happened. Oh! Obviously it's Matisse. Yes, it was him at the beginning.

CABANNE: Were you friends?

DUCHAMP: Not at all. I hardly knew him. I met him maybe three times in my life. But his pictures at the Salon d'Automne moved me enormously, the large figures painted red and blue in particular. That was a big thing at the time, you know. It was very striking. Also there was Girieud, who interested me. . . .

CABANNE: He had his moment.

DUCHAMP: Then he was completely forgotten. He had a kind of hieratic quality which attracted me. I don't know where I had been to pick up on this hieratic business. . . !

CABANNE: Aside from the Salon d'Automne, did you go to the galleries?

DUCHAMP: Yes, to the Druct Gallery in the rue Royale, where one saw the latest things of the Intimists, like Bonnard or Vuillard, who were opposed to the Fauves. Also there was Vallotton. I've always had a weakness for him, because he lived at a time when everything was red and green, and because he used the deepest browns, cold, dark tones— he heralded the Cubist palette. I met Picasso only in 1912 or 1913. As to Braque, I hardly knew him. I simply said "hello" to him, but there was no exchange between us. Besides, he was friendly only with people he had known a long time. Also, we were different ages.

CABANNE: I remember something Villon told me about Picasso. When I was talking with him about their meetings in Montmartre, he replied evasively, "I saw him at a distance." And this "distance" between young artists of the same generation, or nearly, who moved in the same circles, surprised me. It's true that Braque and Picasso were already living completely apart, shut up in both their neighborhood and their art, and hardly leaving one or the other.

DUCHAMP: That's true. Paris was very divided then, and Braque's and Picasso's neighborhood, Montmartre, was very much separated from the others. I had the chance to visit it a little at the time, with Princet. Princet was an extraordinary being. He was an ordinary mathematics teacher in a public school, or something like that, but he played at

being a man who knew the fourth dimension by heart. So people listened. Metzinger, who was intelligent, used him a lot. The fourth dimension became a thing you talked about, without knowing what it meant. In fact, it's still done.

CABANNE: Who were your buddies at that time?

DUCHAMP: Being with Villon out in Neuilly, I had very few. I remember going to Bullier[2] and seeing Delaunay from a distance, making a big speech, but I didn't meet him then.

CABANNE: In going to live in Neuilly, which, for you, was then the end of the earth, did you want to keep a distance between these painters and yourself?

DUCHAMP: Probably. I did very little painting between 1909 and 1910. At the end of 1911 I met Gleizes, Metzinger, and Léger, who moved in the same circle. There were Tuesday meetings at Gleizes', in Courbevoie. He was working with Metzinger on their book about Cubism. There were also the Sundays at Puteaux, where, because of my brothers, who knew the whole Salon d'Automne set, there were many visitors. Cocteau came there from time to time. There was also an amazing fellow, Martin Barzun. I see him sometimes in the United States. Every year, he puts out an enormous book in French and English containing his entire work since 1907. Everything's in there. He must be over eighty now. His son, Jacques, who is completely American, is an official at Columbia University in New York City.

CABANNE: Did you know Apollinaire?

DUCHAMP: Very little. It wasn't easy to know him well, unless you were his intimate. He was a butterfly. He would be talking to you about Cubism, then the next day he was reading aloud from Victor Hugo in a salon. The amusing thing about the literary people of that time was that, when you met two authors, you couldn't get a word in edgewise. It was a series of fireworks, jokes, lies, all untoppable because it was in such a style that you were incapable of speaking their language; so, you kept quiet. One day, I went with Picabia to have lunch with Max Jacob and Apollinaire—it was unbelievable. One was torn between a sort of anguish and an insane laughter. Both of them were still living like writers of the Symbolist period, around 1880, that is.

CABANNE: You exhibited for the first time at the Salon des Indépendants in 1909, two canvases . . .

DUCHAMP: . . . one of which was a little landscape of Saint Cloud, which I sold for a hundred francs. I was enchanted. It was marvelous. With

[2] A well-known Montparnasse dancing hall at the time. [Trans.]

no "finagling." I don't even know who bought it. Then, in the Salon d'Automne of 1910 or 1911, I sold a small canvas, a sketch of a nude, to Isadora Duncan, without my knowing her. Later, I tried to find the picture again. I met Isadora in the United States, but the matter didn't come up. She had bought it to give to one of her friends as a Christmas present. I don't know what became of it.

CABANNE: At that time, what did you understand "the painter's life" to be?

DUCHAMP: First of all, I didn't have a "painter's life," at that point. That came only in 1910.

CABANNE: You were heading toward painting. What did you expect from it?

DUCHAMP: I have no idea. I really had no program, or any established plan. I didn't even ask myself if I should sell my paintings or not. There was no theoretical substratum. Do you understand what I mean? Things were sort of Bohemian in Montmartre—one lived, one painted, one was a painter—all that doesn't mean anything, fundamentally. Certainly it still goes on today. One is a painter because one wants so-called freedom; one doesn't want to go to the office every morning.

CABANNE: Like a sort of refusal of social life.

DUCHAMP: Yes. Absolutely. But there was no farsighted plan of what was going to happen.

CABANNE: You didn't worry about tomorrow.

DUCHAMP: No, absolutely not.

CABANNE: In 1908, you moved in at Neuilly—it was also the year of Cubism. In the autumn, following a show at Kahnweiler's gallery of landscapes that Braque painted at Estaque, Louis Vauxcelles wrote the word "cubism" for the first time. A few months earlier, Picasso had finished "Les Demoiselles d'Avignon." Were you aware of the considerable revolution that painting announced?

DUCHAMP: Not at all. We never saw "Les Demoiselles." It was not shown until a few years later. As for me, I went sometimes to Kahnweiler's gallery in the rue Vignon, and it was there that Cubism got me.

CABANNE: Braque's Cubism.

DUCHAMP: Yes. I was even in his studio, in Montmartre, a little later, toward 1910 or 1911.

CABANNE: You never went to Picasso's?

DUCHAMP: At that time, no.

CABANNE: Didn't he seem an exceptional painter to you?

DUCHAMP: Absolutely not. On the contrary. There was a sort of mental concurrence, so to speak, between Picasso and Metzinger. When Cubism began to take a social form, Metzinger was especially talked about. He explained Cubism, while Picasso never explained anything.

It took a few years to see that not talking was better than talking too much. All of which didn't keep Metzinger from having great respect for Picasso at that time. I don't know what Metzinger lacked afterward, because, of all the Cubists, he was the nearest to a formula for synthesis. Which didn't work. Why? I don't know.

It was later that Picasso became the banner. The public always needs a banner; whether it be Picasso, Einstein, or some other. After all, the public represents half of the matter.

CABANNE: You just said that Cubism got you. When?

DUCHAMP: Around 1911. It was at that time I abandoned the Fauvist side to come around to that thing I had seen, which interested me and which was Cubism. I took it very seriously.

CABANNE: But with distrust. It was, however, a feeling shared by Villon and Duchamp-Villon. . . .

DUCHAMP: A distrust of systematization. I've never been able to contain myself enough to accept established formulas, to copy, or to be influenced, to the point of recalling something seen the night before in a gallery window.

CABANNE: There is a total break between "The Chess Game" of August 1910, which is still very academic, and the "Sonata," and "Portrait, or Dulcinea," of 1911.

DUCHAMP: A total break. "The Chess Game" was in the Salon d'Automne of 1910, and it was in January 1911 that I painted the "Sonata." I retouched it later, in September. The "Dulcinea," five silhouettes of women, one above the other, was done at the same time. What is especially surprising is the technical wishy-washiness.

CABANNE: You were hesitant about taking sides.

DUCHAMP: Yes, because to adapt the new Cubist tecnnique I had to work by hand.

CABANNE: In effect, the Cubist technique seems to have tempted you more than the spirit of Cubism—that is, restoring the shape of the canvas through volume.

DUCHAMP: That's it.

CABANNE: Much more than through color. I notice you said "work by hand," but I'd like to know what shock had determined the break with the painting you were doing before?

DUCHAMP: I don't know. It's probably having seen certain things at Kahnweiler's gallery.

CABANNE: After "The Chess Game," there were, in September-October 1911, several studies in charcoal and oil for "The Chess Players," which preceded the "Portrait of Chess Players," done in December.

DUCHAMP: Yes, all that was in October–November 1911. There was that sketch now in the Museum of Modern Art in Paris, and then there were three or four drawings done even before that sketch. Afterward, there was the largest of the "Chess Players," the definitive one, my brothers playing the game, which is in the Philadelphia Museum. This "Chess Players," or rather "Portrait of Chess Players," is more finished, and was painted by gaslight. It was a tempting experiment. You know, that gaslight from the old Aver jet is green; I wanted to see what the changing of colors would do. When you paint in green light and then, the next day, you look at it in daylight, it's a lot more mauve, gray, more like what the Cubists were painting at the time. It was an easy way of getting a lowering of tones, a *grisaille*.

CABANNE: It's one of the rare times when you were preoccupied with problems of light.

DUCHAMP: Yes, but it isn't even really light; it's light that illuminated me.

CABANNE: It's the atmosphere much more than the light source.

DUCHAMP: Yes, that's it.

CABANNE: Your "Chess Players" are highly influenced by Cézanne's "Card Players."

DUCHAMP: Yes, but I already wanted to get out of that. And then, you know, it all happened very swiftly. Cubism interested me for only a few months. At the end of 1912 I was already thinking of something else. So it was a form of experiment, more than a conviction. From 1902 to 1910, I didn't just float along! I had had eight years of swimming lessons.

CABANNE: Did Villon influence you?

DUCHAMP: At first, very much with his drawings; I really admired his extraordinary manual facility.

CABANNE: During these years, when painters were living in groups, even cliques, exchanging their research, their discoveries, their misgivings, and when friendship played a considerable role, what strikes me is your need for freedom, your taste for distance, for retirement. Despite influences which lasted only briefly, your distance was not only in regard to movements, styles, and ideas, but also to artists themselves. Nevertheless, you were perfectly acquainted with these movements, and didn't hesitate to borrow what could serve to elaborate your own language. What feeling prompted you during that period?

DUCHAMP: An extraordinary curiosity.

Eight Years of Swimming Lessons

2. A Window onto Something Else

PIERRE CABANNE: The curious, but hardly revolutionary, young painter that you were in 1911 must have regarded with interest the step you had just taken. One thing that strikes me about your two works of that year, the "Portrait, or Dulcinea," and the "Sonata," is the appearance of simultaneity.

MARCEL DUCHAMP: It was probably my interpretation of Cubism at that moment. There was also my ignorance of perspective and of the normal placing of figures. The repetition of the same person four or five times, nude, dressed, and in the shape of a bouquet in "Dulcinea," was primarily intended, at that time, to "detheorize" Cubism in order to give it a freer interpretation.

CABANNE: If I mentioned simultaneity, it's because Delaunay painted "The Window on the Town," #3, at that time, which was the first appearance of the simultaneous contrasts that he developed later.

DUCHAMP: I knew Delaunay by name, not more. But be careful, because simultaneity is not movement, or at least not movement as I understand it. Simultaneity is a technique for construction, color construction. Delaunay's "Eiffel Tower" is, in short, a dislocation of the Eiffel Tower, one that could fall. No one was bothering very much with the idea of movement, not even the Futurists. In the first place, they were in Italy, and they weren't very well known.

CABANNE: The Futurist Manifesto had appeared in the *Figaro* of February 20, 1910—hadn't you read it?

DUCHAMP: At the time I didn't go in for such things. And Italy was a long way away. Moreover, the word "Futurism" hardly appealed to me. I don't know how it happened but, after "Dulcinea," I felt the need to do still another small canvas, called "Yvonne and Madeleine Torn Up in Tatters." In this case, it's more tearing than it is movement. This tearing was fundamentally an interpretation of Cubist dislocation.

CABANNE: So there is, on one hand, the Cubist decomposition, and on the other, simultaneity, which is not at all Cubist?

DUCHAMP: No, it isn't Cubist. Picasso and Braque never went in for it. I must have seen Delaunay's "The Windows" in 1911, at the Salon des Indépendants, where I believe the "Eiffel Tower" also was. That "Eiffel Tower" must have moved me, since Apollinaire said in his book on Cubism that I was influenced by Braque, and by Delaunay. Great! When one goes to see people, one is influenced even if one doesn't think about it!

CABANNE: Sometimes the influence comes out later.

DUCHAMP: Yes, forty years later! Movement, or rather the successive images of the body in movement, appeared in my paintings only two or three months later, in October 1911, when I was thinking about doing the "Sad Young Man on a Train."

First, there's the idea of the movement of the train, and then that of the sad young man who is in a corridor and who is moving about; thus there are two parallel movements corresponding to each other. Then, there is the distortion of the young man—I had called this elementary parallelism. It was a formal decomposition; that is, linear elements following each other like parallels and distorting the object. The object is completely stretched out, as if elastic. The lines follow each other in parallels, while changing subtly to form the movement, or the form of the young man in question. I also used this procedure in the "Nude Descending a Staircase."

The "Sad Young Man on a Train"[1] already showed my intention of introducing humor into painting, or, in any case, the humor of word play: *triste*, train. I think Apollinaire called the picture "Melancholy in a Train." The young man is sad because there is a train that comes afterward. "Tr" is very important.

CABANNE: The "Sad Young Man" was finished in December 1911; meanwhile you had tried illustrating a few poems by Jules Laforgue. I suppose on your own initiative. . . .

DUCHAMP: Yes, it was amusing to try that. I liked Laforgue very much.

[1] The title in French is "Jeune homme triste dans un train." [Ed.]

I wasn't very, very literary at the time. I read a little, especially Mallarmé. I liked Laforgue a lot, and I like him even more now, although his public stock has gone way down. What especially interested me was the humor of his *Moralités Légendaires.*

CABANNE: Perhaps a certain resemblance to your own fate: a bourgeois family, a traditional development. And then, adventure. . . .

DUCHAMP: No, not at all. How about the families of other painters of the time? My father was a notary; so was Cocteau's. The same social level. I'm not acquainted with Laforgue's life. I knew that he had been to Berlin. That didn't interest me enormously. But the prose poems in *Moralités Légendaires*, which were as poetic as his poems, had really interested me very much. It was like an exit from Symbolism.

CABANNE: Did you do many illustrations for Laforgue?

DUCHAMP: About ten. I don't even know where they are. I think Breton has one of them, called "Mediocrity." There was also a "Nude Ascending a Staircase," from which came the idea for the painting I did a few months after. . . .

CABANNE: Is it the one called "Again to This Star"?

DUCHAMP: Yes, that's it. In the painting, I represented the "Nude" in the process of descending—it was more pictorial, more majestic.

CABANNE: How did that painting originate?

DUCHAMP: In the nude itself. To do a nude different from the classic reclining or standing nude, and to put it in motion. There was something funny there, but it wasn't at all funny when I did it. Movement appeared like an argument to make me decide to do it.

In the "Nude Descending a Staircase," I wanted to create a static image of movement: movement is an abstraction, a deduction articulated within the painting, without our knowing if a real person is or isn't descending an equally real staircase. Fundamentally, movement is in the eye of the spectator, who incorporates it into the painting.

CABANNE: Apollinaire wrote that you were the only painter of the modern school who concerns himself today—it was the autumn of 1912—with the nude.

DUCHAMP: You know, he wrote whatever came into his head. Anyway, I like what he did very much, because it didn't have the formalism of certain critics.

CABANNE: You declared to Katherine Dreier that, when the vision of the "Nude Descending a Staircase" came to you, you understood that it "was breaking the chains of naturalism forever. . . ."

DUCHAMP: Yes. That was what one said in 1945. I was explaining that,

when you wanted to show an airplane in flight, you didn't paint a still life. The movement of form in time inevitably ushered us into geometry and mathematics. It's the same as when you build a machine. . . .

CABANNE: The moment you finished the "Nude Descending a Staircase," you did the "Coffee Grinder," which anticipates the mechanical drawings.

DUCHAMP: That is more important to me. The origins are simple. My brother had a kitchen in his little house in Puteaux, and he had the idea of decorating it with pictures by his buddies. He asked Gleizes, Metzinger, La Fresnaye, and, I think, Léger, to do some little paintings of the same size, like a sort of frieze. He asked me too, and I did a coffee grinder which I made to explode; the coffee is tumbling down beside it; the gear wheels are above, and the knob is seen simultaneously at several points in its circuit, with an arrow to indicate movement. Without knowing it, I had opened a window onto something else.

That arrow was an innovation that pleased me a lot—the diagrammatic aspect was interesting from an aesthetic point of view.

CABANNE: It had no symbolic significance?

DUCHAMP: None at all. Unless that which consists in introducing slightly new methods into painting. It was a sort of loophole. You know, I've always felt this need to escape myself. . . .

CABANNE: What did the painters you knew think of these experiments?

DUCHAMP: Not much.

CABANNE: Did they consider you a painter?

DUCHAMP: For my brothers, there was no question. They didn't even discuss it. Besides, we didn't talk about those things very much. . . .

You remember that the "Nude Descending a Staircase" had been refused by the Indépendants in 1912. Gleizes was back of that. The picture had caused such a scandal that before the opening he instructed my brothers to ask me to withdraw the painting. So you see . . .

CABANNE: Did that gesture count among the reasons that pushed you to adopt an antiartistic attitude later?

DUCHAMP: It helped liberate me completely from the past, in the personal sense of the word. I said, "All right, since it's like that, there's no question of joining a group—I'm going to count on no one but myself, alone."

A little later, the "Nude" was shown at the Dalmau Gallery, in Barcelona. I didn't go down there, but I read an article in which the painting was mentioned as a kind of special case, the case of the "Nude Descending a Staircase," but it didn't cause a stir.

CABANNE: It was the first time you had upset the established order of things. I wonder if the quiet, even prudent man that you were until then hadn't been a little "upset" in turn by a meeting which had occurred some time earlier, your meeting Picabia.

DUCHAMP: I met him in October of 1911, at the Salon d'Automne, where he had submitted a large "machine," some bathers. Pierre Dumont, whose life was to become so tragic, was there. He introduced us and our friendship began right there. Afterward I saw a lot of Picabia, until his death.

CABANNE: I think the Duchamp-Picabia meeting largely determined the break that you were in the process of making with the conventional forms you were using before.

DUCHAMP: Yes, because Picabia had an amazing spirit.

CABANNE: He was a sort of awakener. . . .

DUCHAMP: A negator. With him it was always, "Yes, but . . ." and "No, but . . ." Whatever you said, he contradicted. It was his game. Perhaps he wasn't even aware of it. Obviously he had had to defend himself a little.

CABANNE: I have the impression that Picabia made you understand that the people you knew, at Puteaux, were "professional" painters, living that "artistic life" which, at the time, you already didn't like, and which Picabia detested.[2]

DUCHAMP: Probably. He had entry into a world I knew nothing of. In 1911–1912, he went to smoke opium almost every night. It was a rare thing, even then.

CABANNE: He revealed to you a new idea of the artist.

DUCHAMP: Of men in general, a social milieu I knew nothing about, being a notary's son! Even if I never smoked opium with him. I knew that he drank enormously too. It was something completely new, in a milieu which was that of neither the Rotonde nor the Dôme.[3]

Obviously, it opened up new horizons for me. And, because I was ready to welcome everything, I learned a lot from it. . . .

CABANNE: Because fundamentally Jacques Villon and Duchamp-Villon were "set" in painting, as Gleizes was. . . .

DUCHAMP: Yes, they had been for ten years. They always needed to explain their least "gestures," in the usual sense of the word.

CABANNE: Socially, aesthetically, sentimentally, the meeting with Picabia was for you the end of something, and the appearance of a new attitude.

[2] Picabia had a considerable private income. [Ed.]

[3] The Bohemian cafés. [Ed.]

DUCHAMP: It all coincided.

CABANNE: I have noticed in your paintings of 1910–1912 a kind of restlessness when it comes to women. They are always disjointed or torn in pieces. Wasn't that revenge for an unhappy love affair? I'm letting myself say things . . .

DUCHAMP: No, not at all! "Dulcinea" is a woman I met on the Avenue de Neuilly, whom I saw from time to time going to lunch, but to whom I never spoke. It wasn't even a matter of being able to speak to her. She walked her dog, and she lived in the neighborhood, that's all. I didn't even know her name. No, there was no ill-feeling. . . .

CABANNE: At twenty-five, you were already known as "the bachelor." You had a well-known antifeminist attitude.

DUCHAMP: No, antimarriage, but not antifeminist. On the contrary, I was exceedingly normal. In effect, I had antisocial ideas.

CABANNE: Anticonjugal?

DUCHAMP: Yes, anti all that. There was a budgetary question that came into it, and a very logical bit of reasoning: I had to choose painting, or something else. To be a man of art, or to marry, have children, a country house. . . .

CABANNE: What did you live on? Your pictures?

DUCHAMP: Simple. My father helped me. He helped us all his life.

CABANNE: But he withheld from your inheritance the amounts he had advanced.

DUCHAMP: Yes, that's nice, isn't it? Advice to fathers! Villon, whom he helped a lot, got nothing, whereas my young sister, who had asked for nothing—she lived at home—received a lot. And there were six of us! That's very nice. People laugh when they're told about it. My father did it the way a notary would. Everything was written down. And he had warned us.

CABANNE: The "Sad Young Man in a Train," was that you?

DUCHAMP: Yes, it was autobiographical, a trip I took from Paris to Rouen, alone in a compartment. My pipe was there to identify me.

CABANNE: In 1911, the year you met Picabia, you were at the Théâtre Antoine with him, Apollinaire, and Gabrielle Buffet, Picabia's wife, for the performance of Raymond Roussel's *Impressions of Africa*.

DUCHAMP: It was tremendous. On the stage there was a model and a snake that moved slightly—it was absolutely the madness of the unexpected. I don't remember much of the text. One didn't really listen. It was striking. . . .

CABANNE: Was it the spectacle more than the language that struck you?

DUCHAMP: In effect, yes. Afterward, I read the text and could associate the two.

CABANNE: Perhaps the way Roussel challenged language corresponded to the way you were challenging painting.

DUCHAMP: If you say so! That's great!

CABANNE: Well, I won't insist.

DUCHAMP: Yes, I would insist. It's not for me to decide, but it would be very nice, because that man had done something which really had Rimbaud's revolutionary aspect to it, a secession. It was no longer a question of Symbolism or even of Mallarmé—Roussel knew nothing of all that. And then this amazing person, living shut up in himself in his caravan, the curtains drawn.

CABANNE: Did you know him?

DUCHAMP: I saw him once at the Régence, where he was playing chess, much later.

CABANNE: Chess must have brought you together.

DUCHAMP: The occasion didn't present itself. He seemed very "strait-laced," high collar, dressed in black, very, very Avenue du Bois. No exaggeration. Great simplicity, not at all gaudy. At the time, I had had contact with him through reading and through the theater, which was enough for me to think that I didn't need to become his close friend. What mattered was an attitude, more than an influence, to know how he had done all that, and why. . . . He had an extraordinary life. And he killed himself in the end.

CABANNE: Didn't films influence the "Nude Descending a Staircase?"

DUCHAMP: Yes, of course. That thing of Marey . . .

CABANNE: Chronophotography.

DUCHAMP: Yes. In one of Marey's books, I saw an illustration of how he indicated people who fence, or horses galloping, with a system of dots delineating the different movements. That's how he explained the idea of elementary parallelism. As a formula it seems very pretentious but it's amusing.

That's what gave me the idea for the execution of the "Nude Descending a Staircase." I used this method a little in the sketch, but especially in the final form of the picture. That must have happened between December and January 1912.

At the same time, I retained a lot of Cubism, at least in color harmony. From things I had seen at Braque's or Picasso's. But I was trying to apply a slightly different formula.

CABANNE: In this "Nude Descending a Staircase," didn't the use of chronophotography give you the idea, perhaps unconscious at first, of the mechanization of man as opposed to perceptible beauty?

DUCHAMP: Yes, evidently, that went with it. There is no flesh, only a simplified anatomy, the up and down, the head, the arms and legs. It was a sort of distortion other than that of Cubism. On the tearing in previous canvases, thought was only a slight influence. Also, there was no Futurism, since I didn't know the Futurists—which didn't keep Apollinaire from qualifying the "Sad Young Man" as the Futurist "state of soul." Remember the "states of soul" of Carra and Boccioni. I had never seen them; let's just say that it was a Cubist interpretation of a Futurist formula. . . .

The Futurists, for me, are urban Impressionists who make impressions of the city rather than of the countryside. Nevertheless I was influenced, as one always is, by these things, but I hoped to keep a note personal enough to do my own work.

The parallelism formula I mentioned also played its role in the picture which followed, "The King and the Queen Surrounded by Swift Nudes," the execution of which excited me more than the "Nude Descending a Staircase," but it didn't have the same public repercussion. I don't know why.

CABANNE: Before, there had been "Two Nudes: One Strong and One Swift," a pencil drawing dating from March 1912.

DUCHAMP: I've just been looking for it at Mr. Bomsel's, because I'm going to show it in London. He is a lawyer who bought it from me in 1930. This drawing was a first attempt at "The King and the Queen." It was the same idea, and it was done around June 1912, the painting having been done in July or August. Afterward, I left for Munich.

CABANNE: Is there a tie between "Nude Descending a Staircase" and "The King and Queen Crossed by Swift Nudes?"

DUCHAMP: Very little, but it was even so the same form of thought, if you like. Obviously the difference was in the introduction of the strong nude and the swift nude. Perhaps it was a bit Futurist, because by then I knew about the Futurists, and I changed it into a king and queen. There was the strong nude who was the king; as for the swift nudes, they were the trails which crisscross the painting, which have no anatomical detail, no more than before.

CABANNE: How did you pass from "The King and the Queen Crossed by Nudes at High Speed" to "The King and Queen Crossed by Swift Nudes?"

DUCHAMP: It was literary play. The word "swift"[4] had been used in sports;

<hr>

[4] "Swift" has become the standard translation of Duchamp's French *vite;* but it is obvious from this passage that an alternative, "speedy," makes more Duchampian sense. [Ed.]

A Window onto Something Else

if a man was "swift," he ran well. This amused me. "Swift" is less involved with literature than "at high speed."

CABANNE: On the back of "The King and the Queen Surrounded by Swift Nudes," you depicted "Adam and Eve in Paradise," in a very academic manner.

DUCHAMP: That's much earlier. That was made in 1910.

CABANNE: You voluntarily painted on the back of that canvas?

DUCHAMP: Yes, because I didn't have any others, and I wasn't enough of a technician to know that it would crack as it has. It's fantastic, it's turned into a puzzle, and people say it won't hold up much longer.

CABANNE: There are some remarkable restoring methods.

DUCHAMP: You'd have to put gouache in each crack, which can be done, but it's a hell of a job. . . . You know, it really looks like something that was made in 1450!

CABANNE: From the spring of 1912 to that of 1913, you knew a period of intense work. One notes a dozen essential works: "Two Nudes, One Strong and One Swift," "The King and the Queen Crossed by Nudes at High Speed" and "The King and the Queen Crossed by Swift Nudes," "The King and the Queen Surrounded by Swift Nudes," "Virgin No. 1" and "Virgin No. 2," "The Passage from the Virgin to the Bride," the first study for "The Bride Stripped Bare by Her Bachelors," the first researches for the "Bachelor Machine," the first mock-up of the "Large Glass," "The Bride Stripped Bare by Her Bachelors, Even," and finally, "Three Standard Stoppages," and the "Chocolate Grinder. . . ."

DUCHAMP: Ugh!

CABANNE: In the "Bachelor Machine," you again took up the idea of the "Coffee Grinder," but by abandoning the conventional forms, which you had respected in the beginning, for a personal system of measurement and spatial calculation, which was going to have more and more importance in your work.

DUCHAMP: That was the end of 1912, I think.

CABANNE: During July and August, you stayed in Munich, where you made the drawings for the "Virgin" and the "Passage from the Virgin to the Bride." Then when you returned, you and Picabia and Gabrielle Buffet drove to see her mother in the Juras.

DUCHAMP: The idea of the "Bride" preoccupied me. So I made a first drawing in pencil, "Virgin No. 1," then a second, "Virgin No. 2," touched up with wash and a little water-color. Then a canvas, and then I went on to the idea of the "Bride and the Bachelors." The drawings I made were still the same type as the "Nude Descending a Staircase,"

and not at all like the one that followed after, with the measured things.

The "Chocolate Grinder" must date from January 1913. We were always going back to Rouen together for holidays. I saw this chocolate grinder in a chocolate shop in the rue des Carmes. So I must have made it when I came back, in January.

CABANNE: Was it made before the "Bachelor Machine"?

DUCHAMP: It was at the same time, since it suggests the same idea—the Bride had to appear there. I was collecting different ideas so I could put them together.

That first "Chocolate Grinder" is completely painted, whereas in the second version, not only is a thread glued with paint and varnish, but it's sewn into the canvas at each intersection. I moved from Neuilly in October 1913 and settled in Paris in a small studio in a new house on the rue Saint-Hippolyte. It was on the wall of this studio that I drew the final sketch of the measurements and exact placements of the "Chocolate Grinder," and a little later the first big drawing for "The Bride Stripped Bare," following the sketch that figures in the "Network of Stoppages" of the same period.

CABANNE: In which three compositions were superimposed; first, the enlarged replica of "Young Man and Young Girl in Spring," shown at the Salon d'Automne in 1911; then vertically, but on the other side, the layout of the "Large Glass" with the measurements; and then, horizontally, the "Network of Stoppages." . . . How do you explain your evolution toward the system of measurements in "The Bride" and the "Large Glass"?

DUCHAMP: I explain it with "The Coffee Grinder." It was there I began to think I could avoid all contact with traditional pictorial painting, which is found even in Cubism and in my own "Nude Descending a Staircase."

I was able to get rid of tradition by this linear method, or this technical method, which finally detached me from elementary parallelism. That was finished. Fundamentally, I had a mania for change, like Picabia. One does something for six months, a year, and one goes on to something else. That's what Picabia did all his life.

CABANNE: It was then that Apollinaire's book *The Cubist Painters* appeared, in which there is this amazing sentence: "It will perhaps be reserved for an artist as disengaged from aesthetic preoccupations, as occupied with energy as Marcel Duchamp, to reconcile Art and the People."

DUCHAMP: I told you: he would say anything. Nothing could have given him the basis for writing such a sentence. Let's say that he sometimes

guessed what I was going to do, but "to reconcile Art and the People," what a joke! That's all Apollinaire! At the time, I wasn't very important in the group, so he said to himself, "I have to write a little about him, about his friendship with Picabia." He wrote whatever came to him. It was no doubt poetic, in his opinion, but neither truthful nor exactly analytical. Apollinaire had guts, he saw things, he imagined others which were very good, but that assertion is his, not mine.

CABANNE: Especially since, at that time, you hardly bothered with communication with the public.

DUCHAMP: I couldn't have cared less.

CABANNE: I have noted that, up until "The Bride," your research was expressed in representations, in illustrations of the duration of time. Beginning with "The Bride," one has the impression that dynamic movement has stopped. It's somewhat as if the means took the place of the function.

DUCHAMP: That's fair enough. I completely forgot the idea of movement, or even of recording movement in one way or another. That didn't interest me any more. It was finished. In "The Bride," in the "Glass," I tried constantly to find something which would not recall what had happened before. I have had an obsession about not using the same things. One has to be on guard because, despite oneself, one can become invaded by things of the past. Without wanting to, one puts in some detail. There, it was a constant battle to make an exact and complete break.

CABANNE: What is the cerebral genesis of the "Large Glass"?

DUCHAMP: I don't know. These things are often technical. As a ground, the glass interested me a lot, because of its transparency. That was already a lot. Then, color, which, when put on glass, is visible from the other side, and loses its chance to oxidize if you enclose it. The color stays pure-looking as long as physically possible. All that constituted technical matters, which had their importance.

In addition, perspective was very important. The "Large Glass" constitutes a rehabilitation of perspective, which had then been completely ignored and disparaged. For me, perspective became absolutely scientific.

CABANNE: It was no longer realistic perspective.

DUCHAMP: No. It's a mathematical, scientific perspective.

CABANNE: Was it based on calculations?

DUCHAMP: Yes, and on dimensions. These were the important elements. What I put inside was what, will you tell me? I was mixing story, anecdote (in the good sense of the word), with visual representation,

while giving less importance to visuality, to the visual element, than one generally gives in painting. Already I didn't want to be preoccupied with visual language. . . .

CABANNE: Retinal.

DUCHAMP: Consequently, retinal. Everything was becoming conceptual, that is, it depended on things other than the retina.

CABANNE: Nevertheless, one has the impression that technical problems came before the idea.

DUCHAMP: Often, yes. Fundamentally, there are very few ideas. Mostly, it's little technical problems with the elements that I use, like glass, etc. They force me to elaborate.

CABANNE: It's odd that you, who are taken for a purely cerebral painter, have always been preoccupied with technical problems.

DUCHAMP: Yes. You know, a painter is always a sort of craftsman.

CABANNE: More than technical problems, there are some scientific problems that you tackle, problems of relations, calculations.

DUCHAMP: All painting, beginning with Impressionism, is antiscientific, even Seurat. I was interested in introducing the precise and exact aspect of science, which hadn't often been done, or at least hadn't been talked about very much. It wasn't for love of science that I did this; on the contrary, it was rather in order to discredit it, mildly, lightly, unimportantly. But irony was present.

CABANNE: On this scientific side, you have considerable knowledge. . . .

DUCHAMP: Very little. I never was the scientific type.

CABANNE: So little? Your mathematical abilities are astonishing, especially since you didn't have a scientific upbringing.

DUCHAMP: No, not at all. What we were interested in at the time was the fourth dimension. In the "Green Box" there are heaps of notes on the fourth dimension.

Do you remember someone called, I think, Povolowski? He was a publisher, in the rue Bonaparte. I don't remember his name exactly. He had written some articles in a magazine popularizing the fourth dimension, to explain that there are flat beings who have only two dimensions, etc. It was very amusing, appearing at the same time as Cubism and Princet.

CABANNE: Princet was a fake mathematician—he too practiced irony. . . .

DUCHAMP: Exactly. We weren't mathematicians at all, but we really did believe in Princet. He gave the illusion of knowing a lot of things. Now, I think he was a high-school math teacher. Or in a public school.

In any case, at the time I had tried to read things by Povolowski, who explained measurements, straight lines, curves, etc. That was working

in my head while I worked, although I almost never put any calculations into the "Large Glass." Simply, I thought of the idea of a projection, of an invisible fourth dimension, something you couldn't see with your eyes.

Since I found that one could make a cast shadow from a three-dimensional thing, any object whatsoever—just as the projecting of the sun on the earth makes two dimensions—I thought that, by simple intellectual analogy, the fourth dimension could project an object of three dimensions, or, to put it another way, any three-dimensional object, which we see dispassionately, is a projection of something four-dimensional, something we're not familiar with.

It was a bit of a sophism, but still it was possible. "The Bride" in the "Large Glass" was based on this, as if it were the projection of a four-dimensional object.

CABANNE: You called "The Bride" a "delay in glass."

DUCHAMP: Yes. It was the poetic aspect of the words that I liked. I wanted to give "delay" a poetic sense that I couldn't even explain. It was to avoid saying, "a glass painting," "a glass drawing," "a thing drawn on glass," you understand? The word "delay" pleased me at that point, like a phrase one discovers. It was really poetic, in the most Mallarméan sense of the word, so to speak.

CABANNE: In "The Bride Stripped Bare by Her Bachelors, Even," what does the word "even" mean?

DUCHAMP: Titles in general interested me a lot. At that time, I was becoming literary. Words interested me; and the bringing together of words to which I added a comma and "even," an adverb which makes no sense, since it relates to nothing in the picture or title. Thus it was an adverb in the most beautiful demonstration of adverbness. It has no meaning.

This "antisense" interested me a lot on the poetic level, from the point of view of the sentence. Breton was very pleased by it, and for me this was a sort of consecration. In fact, when I did it, I had no idea of its value. In English, too,[5] "even" is an absolute adverb; it has no sense. All the more possibility of stripping bare. It's a "non-sense."

CABANNE: You seemed rather to have appreciated word play at that time.

DUCHAMP: I was interested, but very mildly. I didn't write.

CABANNE: Was it Roussel's influence?

[5] The original word in French is *même*, but Duchamp lived in New York City for years, and one cannot help thinking of how often many people there end sentences with another senseless adverb, "yet." [Ed.]

DUCHAMP: Yes, surely, although all that hardly resembles Roussel. But he gave me the idea that I too could try something in the sense of which we were speaking; or rather antisense. I didn't even know anything about him, or how he had explained his writing method in a booklet. He tells how, starting with a sentence, he made a word game with kinds of parentheses. Jean Ferry's book, which is remarkable, taught me a lot about Roussel's technique. His word play had a hidden meaning, but not in the Mallarméan or Rimbaudian sense. It was an obscurity of another order.

CABANNE: Did you stop all artistic activity in order to devote yourself completely to the "Large Glass"?

DUCHAMP: Yes. Art was finished for me. Only the "Large Glass" interested me, and obviously there was no question of showing my early works. But I wanted to be free of any material obligation, so I began a career as a librarian, which was a sort of excuse for not being obliged to show up socially. From this point of view, it was really a very clean decision. I wasn't trying to make paintings, or to sell any. I had several years' work ahead of me.

CABANNE: You made five francs a day at the Sainte-Geneviève Library, didn't you?

DUCHAMP: Yes, because I was "kindly" doing it for nothing. For amusement, I also went to take courses at the School of Paleography and Librarianship.

CABANNE: You took that very seriously?

DUCHAMP: Because I thought it was going to last. I knew very well that I would never be able to pass the examination at the school, but I went there as a matter of form. It was a sort of grip on an intellectual position, against the manual servitude of the artist. At the same time, I was doing my calculations for the "Large Glass."

CABANNE: How did the idea of using glass come to you?

DUCHAMP: Through color. When I had painted, I used a big thick glass as a palette and, seeing the colors from the other side, I understood there was something interesting from the point of view of pictorial technique.

After a short while, paintings always get dirty, yellow, or old because of oxidation. Now, my own colors were completely protected, the glass being a means for keeping them both sufficiently pure and unchanged for rather a long time. I immediately applied this glass idea to "The Bride."

CABANNE: The glass has no other significance?

DUCHAMP: No, no, none at all. The glass, being transparent, was able to give its maximum effectiveness to the rigidity of perspective. It also

took away any idea of "the hand," of materials. I wanted to change, to have a new approach.

CABANNE: Several interpretations of the "Large Glass" have been given. What is yours?

DUCHAMP: I don't have any, because I made it without an idea. There were things that came along as I worked. The idea of the ensemble was purely and simply the execution, more than descriptions of each part in the manner of the catalogue of the "Arms of Saint-Etienne."[6] It was a renunciation of all aesthetics, in the ordinary sense of the word ... not just another manifesto of new painting.

CABANNE: It's a sum of experiments?

DUCHAMP: A sum of experiments, yes, without the influence of the idea of creating another movement in painting, in the sense of Impressionism, Fauvism, etc., any kind of "ism."

CABANNE: What do you think of the different interpretations given by Breton, Michel Carrouges, or Lebel?

DUCHAMP: Each of them gives his particular note to his interpretation, which isn't necessarily true or false, which is interesting, but only interesting when you consider the man who wrote the interpretation, as always. The same thing goes for the people who have written about Impressionism. You believe one or you believe another, according to the one you feel closest to.

CABANNE: So, fundamentally, you're indifferent to what is written about you.

DUCHAMP: No, no, I'm interested.

CABANNE: You read it?

DUCHAMP: Certainly. But I forget.

CABANNE: The astonishing thing is that, for eight years, from 1915 to 1923, you succeeded in having so many irons in the fire the spirits, formation, and ends of which were completely opposed. Thus, the rigorous, progressive, and slow elaboration of the "Large Glass," the methodological concentration of the "Box," and the offhandedness of the first readymades.

DUCHAMP: For the "Box" of 1913–1914, it's different. I didn't have the idea of a box as much as just notes. I thought I could collect, in an album like the Saint-Etienne catalogue, some calculations, some reflexions, without relating them. Sometimes they're on torn pieces of paper. . . . I wanted that album to go with the "Glass," and to be consulted when seeing the "Glass" because, as I see it, it must not be

[6] A sort of French "Sears, Roebuck." (Trans.)

"looked at" in the aesthetic sense of the word. One must consult the book, and see the two together. The conjunction of the two things entirely removes the retinal aspect that I don't like. It was very logical.

CABANNE: Where does your antiretinal attitude come from?

DUCHAMP: From too great an importance given to the retinal.[7] Since Courbet, it's been believed that painting is addressed to the retina. That was everyone's error. The retinal shudder! Before, painting had other functions: it could be religious, philosophical, moral. If I had the chance to take an antiretinal attitude, it unfortunately hasn't changed much; our whole century is completely retinal, except for the Surrealists, who tried to go outside it somewhat. And still, they didn't go so far! In spite of the fact that Breton says he believes in judging from a Surrealist point of view, down deep he's still really interested in painting in the retinal sense. It's absolutely ridiculous. It has to change; it hasn't always been like this.

CABANNE: Your position was considered exemplary, but was hardly followed.

DUCHAMP: Why would you follow it? You can't make money with it.

CABANNE: You could have disciples.

DUCHAMP: No. It isn't a formula for a school of painting in which one follows a master. In my opinion, it was a more elevated position.

CABANNE: What did your friends think of it?

DUCHAMP: I spoke to very few people about it. Picabia was above all an "Abstractionist," a word he had invented. It was his hobbyhorse. We didn't talk much about it. He thought about nothing else. I left it very quickly.

CABANNE: You were never an Abstractionist?

DUCHAMP: Not in the real sense of the word. A canvas like "The Bride" is abstract, since there isn't any figuration. But it isn't abstract in the narrow sense of the word. It's visceral, so to speak.

When you see what the Abstractionists have done since 1940, it's worse than ever, optical. They're really up to their necks in the retina!

CABANNE: Was it in the name of your antiretinal attitude that you refused abstraction?

DUCHAMP: No. I rejected it first and then figured out why afterward.

CABANNE: How were you invited to the Armory Show?

DUCHAMP: By Walter Pach. He had come to France in 1910, and he had made friends with my brothers, through whom we met. Then in 1912,

[7] Duchamp uses the word "retinal" in the way that many people use "painterly"; note, a few sentences further on, his criticism of Breton. In other words, Duchamp objects to the sensuous appeal of painting. [Ed.]

when he was entrusted with the task of gathering paintings for that show, he saved a lot of room for the three of us. It was during the Cubist heyday. We had shown him what we had, and he left. He took four of my things: the "Nude Descending a Staircase," the "Young Man," the "Portrait of Chess Players," and "The King and the Queen Surrounded by Swift Nudes."

Walter Pach had translated Elie Faure into English. He also wrote several very good books. The bad thing was that the poor fellow was a painter. His painting bore no resemblance to anything likable. It was undrinkable. But he was a charming man.

He came back in 1914. It was he who made me decide to go to the United States. War had been declared. We were sitting on a bench on the Avenue des Gobelins in October or November. It was a beautiful day. He said, "Why don't you come to America?" He explained to me that the "Nude Descending a Staircase" had been a success, that I had a possible place over there. That made up my mind—I would leave in six months. I had been discharged from the army, but I had to ask for permission.

CABANNE: Overnight you had become the man of the "Nude Descending a Staircase." Your four pictures had been sold and you were famous. Which contradicted your detachment. . . .

DUCHAMP: It came from so far away! I hadn't gone to the exhibition, I was still here in Paris. I simply received a letter saying that the four pictures were sold. But the success wasn't so important, because it was a local success. I didn't attach much importance to it. I was very happy about selling the "Nude" for two hundred and forty dollars. Two hundred and forty dollars made twelve hundred gold francs: the price I had asked.

What contributed to the interest provoked by that canvas was its title. One just doesn't do a nude woman coming down the stairs, that's ridiculous. It doesn't seem ridiculous now, because it's been talked about so much, but when it was new, it seemed scandalous. A nude should be respected.

It was also offensive on the religious, Puritan level, and all of this contributed to the repercussions of the picture. And then there were painters over there who were squarely opposed to it. That triggered a battle. I profited. That's all.

CABANNE: What do you, more than a half century away, think of that "Nude"?

DUCHAMP: I like it very much. It held up better than "The King and the Queen." Even in the old sense, the painterly sense. It's very involved,

very compact, and very well painted, with some substantial colors a German gave me. They've behaved very well, and that's very important.

CABANNE: Didn't this *succès de scandale* render you somewhat suspect in the eyes of French painters?

DUCHAMP: Yes, probably, but don't forget that they didn't know much about it. Back then, there weren't the kind of communications between Europe and America that we have today, and so no one talked about it, not even in the papers. There were tiny echoes here and there, but that's all. As far as the French were concerned, it went unnoticed.

I hadn't considered the importance this success could have in my life. When I arrived in New York, I realized that I wasn't a stranger at all.

CABANNE: You were a man predestined for America.

DUCHAMP: So to speak, yes.

CABANNE: And you stayed there.

DUCHAMP: It was like a second wind.

CABANNE: It's been said that you were the only painter to awaken an entire continent to a new art.

DUCHAMP: The continent couldn't have cared less! Our milieu was very restricted, even in the United States!

CABANNE: Did you think about what you represented at that period for Americans?

DUCHAMP: Not very much. The tiresome thing was that every time I met someone, they would say, "Oh! Are you the one who did that painting?" The funniest thing is that for at least thirty or forty years the painting was known, but I wasn't. Nobody knew my name. In the continental American sense of the word, "Duchamp" meant nothing. There was no connection between the painting and me.

CABANNE: No one connected the scandal and its author?

DUCHAMP: Not at all. They didn't care. When they met me they said, "Well, fine!" but there were only three or four who knew who I was, whereas everyone had seen the painting or reproductions, without knowing who had painted it. I really lived over there without being bothered by the painting's popularity, hiding behind it, obscured. I had been completely squashed by the "Nude."

CABANNE: Didn't that correspond perfectly to your idea of the artist?

DUCHAMP: I was enchanted. I never suffered from the situation, although I was troubled when I had to answer questions from journalists.

CABANNE: Like today?

DUCHAMP: Like today!

CABANNE: The buyer of the "Nude Descending a Staircase" owned a gallery in San Francisco, an F. C. Torrey. . . .

DUCHAMP: A shop for Chinese antiquities. He had come to see me in Paris before the war, and I gave him the little drawing after Laforgue, the "Nude Ascending a Staircase," which, furthermore, wasn't called that, but "Again to This Star." It represented a nude going up the stairs, and it is, you know, the original idea in reverse of the "Nude Descending." I had put a stupid date below, 1912, when it had been done in November of 1911, and I dedicated it to Torrey in 1913. When you compare the dates, you say, "that's impossible." An amusing mess.

For five years, Arensberg asked Torrey to sell him that drawing, and finally he did. I don't know how much it cost—that was a secret. I never asked him. Perhaps he wouldn't have told me. He must have paid through the nose at that time.

CABANNE: Two other canvases shown, "The King and the Queen" and "Portrait of Chess Players," were bought by a Chicago lawyer, A. J. Eddy.

DUCHAMP: He was a funny fellow too! He was the first man in Chicago to ride a bicycle, and the first to have his portrait painted by Whistler. That made his reputation![8] He had a very important law practice and a collection of paintings. He bought numerous Abstract paintings at the time, Picabias, too. He was a large fellow, with white hair. He wrote a book, *Cubism and Post-Impressionism*, which was published in 1914, and the first book to have discussed Cubism in the United States.

These people were very amusing because they were unexpected. They never mentioned buying a painting. Walter Pach served as the liaison.

CABANNE: The "Three Standard Stoppages" are made of three sheets of long, narrow glass, on which are glued strips of canvas that serve as the background for three pieces of thread. The whole thing is enclosed in a croquet box. You defined it as "canned chance."

DUCHAMP: The idea of "chance,"[9] which many people were thinking about at the time, struck me too. The intention consisted above all in forgetting the hand, since, fundamentally, even your hand is chance.

Pure chance interested me as a way of going against logical reality: to put something on a canvas, on a bit of paper, to associate the idea of a perpendicular thread a meter long falling from the height of one

[8] Actually, Eddy had written books on art, including an anecdotal account of Whistler (1904). [Ed.]

[9] Fr., *"hazard."* [Trans.]

meter onto a horizontal plane, making its own deformation. This amused me. It's always the idea of "amusement" which causes me to do things, and repeated three times. . . .

For me the number three is important, but simply from the numerical, not the esoteric, point of view: one is unity, two is double, duality, and three is the rest. When you've come to the word three, you have three million—it's the same thing as three. I had decided that the things would be done three times to get what I wanted. My "Three Standard Stoppages" is produced by three separate experiments, and the form of each one is slightly different. I keep the line, and I have a deformed meter. It's a "canned meter," so to speak, canned chance; it's amusing to can chance.

CABANNE: How did you come to choose a mass-produced object, a "readymade," to make a work of art?

DUCHAMP: Please note that I didn't want to make a work of art out of it. The word "readymade" did not appear until 1915, when I went to the United States. It was an interesting word, but when I put a bicycle wheel on a stool, the fork down, there was no idea of a "readymade," or anything else. It was just a distraction. I didn't have any special reason to do it, or any intention of showing it, or describing anything. No, nothing like all that. . . .

CABANNE: But some provocation just the same. . . .

DUCHAMP: No, no. It's very simple. Look at the "Pharmacy." I did it on a train, in half-darkness, at dusk; I was on my way to Rouen in January 1914. There were two little lights in the background of the reproduction of a landscape. By making one red and one green, it resembled a pharmacy.[10] This was the kind of distraction I had in mind.

CABANNE: Is it canned chance, too?

DUCHAMP: Certainly.

I bought the reproduction of the landscape in an artist's supply store. I did only three "Pharmacies," but I don't know where they are. The original belonged to Man Ray.

In 1914, I did the "Bottle Rack." I just bought it, at the bazaar of the town hall. The idea of an inscription came as I was doing it. There was an inscription on the bottle rack which I forget. When I moved from the rue Saint-Hippolyte to leave for the United States, my sister and sister-in-law took everything out, threw it in the garbage, and said no more about it. It was in 1915, especially, in the United States, that

A Window onto Something Else

[10] French pharmacists always used to have jars of colored water (especially red and green) in their windows. [Trans.]

I did other objects with inscriptions, like the snow shovel, on which I wrote something in English. The word "readymade" thrust itself on me then. It seemed perfect for these things that weren't works of art, that weren't sketches, and to which no art terms applied. That's why I was tempted to make them.

CABANNE: What determined your choice of readymades?

DUCHAMP: That depended on the object. In general, I had to beware of its "look." It's very difficult to choose an object, because, at the end of fifteen days, you begin to like it or to hate it. You have to approach something with an indifference, as if you had no aesthetic emotion. The choice of readymades is always based on visual indifference and, at the same time, on the total absence of good or bad taste.

CABANNE: What is taste for you?

DUCHAMP: A habit. The repetition of something already accepted. If you start something over several times, it becomes taste. Good or bad, it's the same thing, it's still taste.

CABANNE: What have you done to escape taste?

DUCHAMP: Mechanical drawing. It upholds no taste, since it is outside all pictorial convention.

CABANNE: You constantly defended yourself against the realization . . .

DUCHAMP: . . . of making a form in the aesthetic sense, of making a form or a color. And of repeating them.

CABANNE: It's an antinaturalist attitude, which you nonetheless exercised on natural objects.

DUCHAMP: Yes, but that's all the same to me; I'm not responsible. It was made, I wasn't the one who made it. There is a defense; I object to responsibility.

CABANNE: You continued elaborating the "Large Glass," with the "Three Malic Moulds." . . .

DUCHAMP: No, there were nine of them.

CABANNE: Right. But you started by making three. Almost at the same time as the "Three Standard Stoppages," and perhaps for the same reason.

DUCHAMP: No, at first I thought of eight and I thought, that's not a multiple of three. It didn't go with my idea of threes. I added one, which made nine. There were nine "Malic Moulds." How did they come? I did a drawing, in 1913, in which there were eight—the ninth wasn't yet there. It came six months later.

The idea is amusing because they are molds. And to mold what? Gas. That is, gas is introduced into the molds, where it takes the shape of the soldier, the department-store delivery boy, the cuirassier, the policeman,

the priest, the station master, etc., which are inscribed on my drawing. Each is built on a common horizontal plane, where lines intersect at the point of their sex.

All that helped me realize the glass entitled "Nine Malic Moulds," which was made in 1914–1915. The mold side is invisible. I always avoided doing something tangible, but with a mold it doesn't matter, because it's the inside I didn't want to show.

The "Nine Malic Moulds" were done in lead; they are not painted, they are each waiting to be given a color. I denied myself the use of color: lead is a color without being one. This is the kind of thing I was working on at that time.

CABANNE: You have compared the readymade to a sort of rendezvous.

DUCHAMP: Once, yes. At that time, I was preoccupied with the idea of doing a certain thing in advance, of declaring "at such and such an hour I'll do this. . . ." I never did it. I would have been embarrassed by it.

CABANNE: At the time when you arrived in America, in June 1915, how was New York?

DUCHAMP: It was different from Paris. A little bit provincial. There were many small French restaurants, small French hotels, which have disappeared. Everything changed in 1929 with the crash. Taxes were introduced. You couldn't do anything, as in France now, without being obliged to think about the taxes you must pay. And then there were the unions, etc. I saw a little of what America must have been in the nineteenth century.

CABANNE: Academism was triumphant in painting. . . .

DUCHAMP: Yes, the "French artists." Fundamentally. Furthermore, painters were coming to study at the Beaux-Arts in Paris, etc. Mr. Vanderbilt had come to Paris in 1900 to buy a Bouguereau for one hundred thousand dollars. He had also paid sixty thousand dollars for a Rosa Bonheur. Others had bought Meissonier, Henner, Sargent. It was "the grand style" of living.

CABANNE: Did the Armory Show change American opinion?

DUCHAMP: Surely. It changed the spirit in which artists worked, and, equally, woke people up to the idea of art in a country where there had been little interest before. Only a moneyed elite bought paintings from Europe. For the big collectors, there never was any question of buying an American painting. However, they had a flowering of painters, not only very interesting and very intelligent, but also very much in touch with what was happening in Paris. . . .

CABANNE: It's been said that you had arrived in the United States as a missionary of insolence.

DUCHAMP: I don't know who said that, but I agree! Still, I wasn't all that insolent, and my social life was very narrow. It was very quiet, you know, not at all aggressive or rebellious. We lived completely outside of social ideas or political movements.

CABANNE: Henri-Pierre Roché told me that you exercised a kind of fascination.

DUCHAMP: Oh, he was very nice. From the moment we met, he called me "Victor," and three hours later, "Totor." And that's what he called me the rest of his life. I don't think you can call that being fascinated.

Through the "Large Glass"

PIERRE CABANNE: By 1915 you were in New York. You were twenty-eight years old, and the famous author of a painting whose fame was no less great, the "Nude Descending a Staircase." On your arrival, you made the acquaintance of your principal American patron, who later brought together your life's work in the Philadelphia Museum: Walter C. Arensberg. How did you meet him?

MARCEL DUCHAMP: When I arrived, Walter Pach was at the boat and took me straight to Arensberg's. Arensberg had known that I was coming to America, and without knowing anything about me, he wanted to meet me. I stayed at his place for a month, during which our friendship was born (afterward, I took my own studio), a friendship which lasted all my life.

He was a very nice boy, originally a poet, a Harvard man who had enough to live on and who wrote Imagist poetry. In New York at that time, there was a school of poetry, the Imagists, who were part of a group of American poets I knew at that point. Arensberg had a difficult character, poor man. He was a little older than I, though not much; and he wasn't recognized very quickly or very completely as a poet. He became disgusted with poetry and soon stopped writing, around 1918–1919. He had a fantastic hobby: cryptography, which consisted of finding the secrets of Dante in the *Divine Comedy*, and the secrets of Shakespeare in his plays. You know, the old story: who is Shakespeare, who isn't Shakespeare. He spent his whole life on it. As for Dante,

Arensberg did a book on him, which he published at his own expense since there was no question of a publisher's doing it. Then he founded a society, the Francis Bacon Foundation, or something like that, to prove that it was really Bacon who had written Shakespeare's plays.

His system was to find, in the text, in every three lines, allusions to all sorts of things; it was a game for him, like chess, which he enjoyed immensely. He had two or three secretaries working for him, and when he died, he left enough money for them to rent a small house in California and continue their research on Shakespeare.

That was Arensberg.

CABANNE: Was his research really scientifically valuable?

DUCHAMP: I don't believe so. I think it was mostly the conviction of a man at play: Arensberg twisted words to make them say what he wanted, like everyone who does that kind of work.

CABANNE: How did Arensberg hear about you?

DUCHAMP: Through the Armory Show. When I arrived, he began buying my things, which wasn't easy, because those who had my things didn't want to sell them. He put in three years getting the "Nude Descending a Staircase"; he bought it in 1918 or 1919; in the meantime, he had asked me to make a photographic copy, which I retouched with pastels and India ink. It's not the work I'm proudest of. . . .

CABANNE: Did you meet Henri-Pierre Roché in New York?

DUCHAMP: Yes, when he came on I don't remember which war commission.

CABANNE: He was sent with a French mission.

DUCHAMP: Charged with a mission, that's it. I met him, and we were always very close. But he didn't live in New York very long.

I did stay, however. I didn't have much money. I wanted to work, so I got a job in the French military mission. Not being a soldier, I was simply a captain's secretary, which I assure you wasn't at all funny. It was horrible; the captain was an idiot. I worked there for six months, and then, one day, I just walked out, because making thirty dollars a week wasn't worth it.

CABANNE: How did you live in New York?

DUCHAMP: I had a studio for a long time on Broadway in a studio building, like the Ruche or something of that sort. It had everything, a drugstore below, a movie theater, etc. It was very cheap, forty dollars a month.

CABANNE: I believe that at Arensberg's you met everybody who was anybody in New York.

DUCHAMP: Nearly. There were Barzun, Roché, Jean Crotti, the composer

Edgard Varèse, Man Ray, and, obviously, a lot of Americans. Then Picabia arrived....

CABANNE: You must have met Arthur Cravan?

DUCHAMP: He arrived at the end of 1915, or in 1916. He made a very brief appearance. Because of his military status he must have had some reckoning to do. No one knew what he had done, and no one wanted to say much about it. Perhaps he scrounged up a passport and beat it for Mexico. These are things people don't talk about. He married, or at least lived with, Mina Loy, an English poetess of the Imagist school—also a friend of Arensberg—who still lives in Arizona. He had a child by her, also in Arizona. Cravan took Mina to Mexico, and then, one day, he took off alone in a boat and was never seen again. She looked for him in all the Mexican prisons, and since he was a boxer, a very big fellow, she thought that he wouldn't be able to lose himself in a crowd, he would have been recognized right away.

CABANNE: He was never seen again?

DUCHAMP: Never. He was a funny type. I didn't like him very much, nor he me. You know, it was he who, writing about one of the Independents' salons, in 1914, horribly insulted everyone in wild terms, Sonia Delaunay and Marie Laurencin in particular.[1] He made a lot of enemies with that....

CABANNE: Did you see a lot of American painters?

DUCHAMP: Yes, they used to spend evenings at Arensberg's, three or four times a week. They played chess—Arensberg played a lot of chess—a fair amount of whisky was drunk. Around midnight, they'd eat some cake, and the evening would end around three in the morning; sometimes, it was a real drinking bout, but not always.... It was truly an artistic salon, rather amusing at that.

CABANNE: What did you represent for the painters?

DUCHAMP: I don't know. I was probably someone who had changed the face of things a little bit, who had helped make the Armory Show. For them, that was important.

CABANNE: You were linked with the revelation of the Armory Show?

DUCHAMP: Oh, yes, completely. For all the artists. And they weren't just the ones who had "arrived"; there were young ones too, much younger than I, who were very interesting. A few were already forming a group of Abstract painters. The most interesting was Arthur Dove. Also there was Alfred Stieglitz, the photographer, whose main characteristic

[1] This insulting piece of Cravan's appears in *The Dada Painters and Poets*. See Bibliography, no. 40. [Ed.]

was being a philosopher, a sort of Socrates. He always spoke in a very moralizing way, and his decisions were important. He didn't amuse me much, and at the beginning I must say he didn't think much of me either; I struck him as a charlatan. He was very bound up with Picabia, whom he had met in 1913; then later he changed his mind about me, and we became good friends. These are things that one cannot explain.

CABANNE: Your first American readymade was called "In Advance of the Broken Arm." Why?

DUCHAMP: It was a snow shovel. In fact, I had written that phrase on it. Obviously I was hoping it was without sense, but deep down everything ends up by having some.

CABANNE: It takes on sense when you have the object itself in front of your eyes.

DUCHAMP: Exactly. But I thought that, especially in English, it really had no importance, no possible relation. An obvious association is easy: you can break your arm shoveling snow, but that's a bit simple-minded, and I didn't think that would be noticed.

CABANNE: In "With Secret Noise," a ball of string squeezed between two brass plates, joined by four long screws, were your intentions the same?

DUCHAMP: The name came after. I did three readymades—it was Easter 1926—and I have lost them. One of them stayed with Arensberg, who put something inside, after loosening the plates. When they were screwed back down, the thing inside made a noise. . . . I never knew what it was. The noise was a secret for me.

CABANNE: The first collaborative readymade came with engraved inscriptions, which were rendered intentionally incomprehensible.

DUCHAMP: They weren't incomprehensible at all; they were French and English words with letters missing. The inscriptions were like signs from which a letter has fallen off. . . .

CABANNE: At the very least it's incomprehensible in reading them: P.G. ECIDES DEBARRASSE LE. D.SERT. F.URNIS ENTS AS HOW. V.R COR.ESPONDS . . .

DUCHAMP: One can be amused putting them back together, it's very easy.

CABANNE: In April 1916 you took part in a New York exhibition called "The Four Musketeers," the three others being Crotti, Metzinger, and Gleizes. You were also among the founding members of the Société des Indépendants, and at the first exhibition you presented a porcelain urinal called "Fountain," signed by R. Mutt, which was rejected.

DUCHAMP: No, not rejected. A work can't be rejected by the Indépendants.

CABANNE: Let's just say that it wasn't admitted.

DUCHAMP: It was simply suppressed. I was on the jury, but I wasn't consulted, because the officials didn't know that it was I who had sent

it; I had written the name "Mutt" on it to avoid connection with the personal. The "Fountain" was simply placed behind a partition and, for the duration of the exhibition, I didn't know where it was. I couldn't say that I had sent the thing, but I think the organizers knew it through gossip. No one dared mention it. I had a falling out with them, and retired from the organization. After the exhibition, we found the "Fountain" again, behind a partition, and I retrieved it!

CABANNE: It's a little like the same adventure you had with the Indépendants in Paris, in 1912.

DUCHAMP: Exactly. I have never been able to do anything that was accepted straight off, but to me that wasn't important.

CABANNE: You say that now, but at the time. . . ?

DUCHAMP: No, no, on the contrary! Still, it was rather provocative.

CABANNE: Well, since you were looking for scandal, you were satisfied?

DUCHAMP: It was, indeed, a success. In that sense.

CABANNE: You really would have been disappointed had the "Fountain" been welcomed. . . .

DUCHAMP: Almost. As it was, I was enchanted. Because fundamentally, I didn't have the traditional attitude of the painter who presents his painting, hoping it will be accepted and then praised by the critics. There never was any criticism. There never was any criticism because the urinal didn't appear in the catalogue.

CABANNE: Arensberg bought it just the same. . . .

DUCHAMP: Yes, and he lost it. A life-size replica has been made since then. It's at the Schwarz gallery, in Milan.[2]

CABANNE: When did you hear about Dada for the first time?

DUCHAMP: In Tzara's book, *The First Celestial Adventure of Mr. Fire Extinguisher*. I think he sent it to us, to me or to Picabia, rather early, in 1917, I think, or at the end of 1916. It interested us but I didn't know what Dada was, or even that the word existed. When Picabia went to France, I learned what it was through his letters, but that was the sole exchange at that time. Then, Tzara showed things by Picabia in Zurich, and Picabia went there before coming back to the United States. Picabia's story is very complicated from the point of view of his travels. He arrived in the United States at the end of 1915, but didn't stay more than three or four months before leaving again for Spain, for Barcelona, where he founded the magazine *391*. It was in Lausanne, in 1918, that he made contact with the Zurich Dadaist group.

[2] A present-day gallery devoted to Dada and Surrealism, and especially to Duchamp, on whom Arturo Schwarz is an authority. [Ed.]

CABANNE: But in the meantime, hadn't he come back to the United States?

DUCHAMP: Yes, in 1917. He published two or three issues of *391* there.

CABANNE: These were the first manifestations of the Dada spirit in America.

DUCHAMP: Absolutely. It was very aggressive.

CABANNE: What kind of aggression?

DUCHAMP: Antiart. It was principally a matter of questioning the artist's behavior, as people envisaged it. The absurdity of technique, of traditional things. . . .

CABANNE: That gave you the idea of publishing, with the help of Arensberg and Roché, two little magazines, *The Blind Man* and *Rongwrong*.

DUCHAMP: But, you know, it wasn't at all *after* seeing Dada things that we did it; on the contrary, it was at the moment of the Indépendants' exhibition, in 1917, in which Picabia was showing.

CABANNE: It was nevertheless in the Dada spirit.

DUCHAMP: It was parallel, if you wish, but not directly influenced. It wasn't Dada, but it was in the same spirit, without, however, being in the Zurich spirit, although Picabia did things in Zurich. Even in typography, we weren't extremely inventive. In *The Blind Man* it was above all a matter of justifying the "Fountain-Urinal." We published two issues, and, between them, there was this little bulletin, *Rongwrong*, which was different. In the whole magazine there was nothing, nothing. It was surprising. There were some little things, with the drawings of an American humorist who did pipes, inventions like a bent rifle for shooting around corners. Nothing extraordinary, simply things one can't describe, you'll be able to refer to them only when you have them before you. I don't have any here; I never kept them. I do know there are a few lying about in collections. Later, in March 1919, Man Ray published another magazine which, again, didn't last very long, *TNT*, *The Explosive Magazine*. He did it with a sculptor, Adolf Wolff, who was imprisoned as an anarchist.

CABANNE: Still, these magazines got results: your "Fountain" became as famous as the "Nude Descending a Staircase."

DUCHAMP: True.

CABANNE: Didn't this fame seem to have any commercial repercussions for you?

DUCHAMP: No, never!

CABANNE: You weren't looking for them?

DUCHAMP: I neither wished for nor looked for them, because it wasn't a question of selling things like that. I was working on my "Glass," which couldn't be sold before being finished, and since that took from 1915 to '23, you see. . . . Sometimes I sold paintings I had in Paris;

Arensberg bought them, one after another.... He also bought the "Nude Descending a Staircase" from Torrey.

CABANNE: Did you know how much he had paid?

DUCHAMP: No, I wasn't interested. I never knew the price. It's the same for "With Secret Noise" . . . what's secret is the price!

He must have paid a lot because of the to-do made about it, but all that money passed over my head.

CABANNE: You were giving French lessons for a living. . . .

DUCHAMP: At one time, I gave many; it wasn't lucrative, but one could live making two dollars an hour. The people I taught were charming. They took me to the theater, sometimes to dinner . . . I was the French professor! Like Laforgue.

CABANNE: I think your behavior stupefied Americans.

DUCHAMP: Yes, because at the time, if they weren't as materialistic as they are now, they were still very much so. But there was a group of people it didn't surprise, some friends especially. I wasn't the kind of painter who sells, who has exhibitions every two years. Still, we had an exhibition with Crotti, Gleizes, Metzinger, as you said. It was in 1916, at the Montross Gallery. Gleizes was rather naïve—he was hoping to find cowboys on Broadway! He stayed in New York a year and a half. Back then, there wasn't the kind of New York art market there is now. Paintings weren't sold just like that. There were very few dealers, three or four, and that's all. There was none of today's feverish atmosphere.

CABANNE: One has the impression that you were both part of a certain fashionable life, and at the same time outside it.

DUCHAMP: Yes, that's true. Fashionable is exaggerated. Rather, salons, if you like, literary salons. There weren't many of them, but one would meet amusing people, like Katherine Dreier, with whom I got the Société Anonyme going. I met her in 1917. She helped organize the Indépendants. She was part of the jury, I think. She was German or at least of German origin, and that gave her some trouble.

CABANNE: This was when the United States was entering the war?

DUCHAMP: Yes, right in 1917. She bought some of my things, but she was particularly interested in the work of German artists, and after the war, when she went to Europe to form the collection of the Société Anonyme, she bought mostly German Expressionists. Everybody who is anybody now—and they were completely unknown then. She also founded the Société Anonyme—Man Ray and I were vice-presidents—which formed an important collection of modern art, not very beautiful but representative of the time. Kandinsky and Archipenko were included, four or five of us altogether.

CABANNE: Not Picabia?

DUCHAMP: No. He was shown, but he wasn't part of the Société.

CABANNE: Was the idea of the Société Anonyme yours?

DUCHAMP: No. Man Ray made up the name. The idea was to create a permanent international collection that would later be left to a museum. Up to 1939, there were eighty-four exhibitions, and lectures, publications. . . .

CABANNE: What became of the collection?

DUCHAMP: During the second war it went to the Yale University Art Gallery.

CABANNE: The idea of collecting art works for a museum was rather anti-Duchamp. Didn't you feel you were repudiating your own opinions?

DUCHAMP: I was doing it for friendship. It wasn't my idea. The fact that I agreed to be a member of a jury which determined what works were chosen didn't involve my opinions at all on that question.

And then, it was a good thing to help artists be seen somewhere. It was more camaraderie than anything else; I didn't think it was very important. Basically there never was a museum. It was expensive, too expensive to have a private museum; thus the solution was to give the whole thing to Yale University.

Over the years, Katherine Dreier took trips to Europe. From time to time she bought things and brought them back. But she was a victim of the 1929 crash, and she didn't have money for buying pictures any more. Especially since their prices were going up then.

CABANNE: How did you live in New York?

DUCHAMP: You know, one doesn't know how one does it. I wasn't getting "so much per month" from anyone. It was really *la vie de bohème*, in a sense, slightly gilded—luxurious if you like, but it was still Bohemian life. Often there wasn't enough money, but that didn't matter. I must also say that it was easier back then in America than now. Camaraderie was general, and things didn't cost much, rent was very cheap. You know, I can't even talk about it, because it didn't strike me to the point of saying, "I'm miserable, I'm leading a dog's life." No, not at all.

CABANNE: You were more on the fringes in Paris before the war than you were in New York, where you were a foreigner.

DUCHAMP: Indeed, I wasn't on the fringes in New York precisely because of the "Nude Descending a Staircase." When I was introduced, I was always the man who had painted the "Nude Descending a Staircase," and people knew who they were talking to.

I knew no one in Paris; I barely knew Delaunay, and I only met him

after the war. In 1912, I had been to see Braque once or twice, and Picasso I had met like that, but there were no exchanges of views among us. Obviously I stayed very much apart, being a librarian at the Sainte-Geneviève Library; and then I had my studio in the rue Saint-Hippolyte, which wasn't really a studio, but a seventh-floor apartment with lots of light. I was already working on my "Glass," which I knew was going to be a long-term project. I had no intention of having shows, or creating an *œuvre*, or living a painter's life.

CABANNE: Still, you accepted the artist's life more easily in New York than in Paris.

DUCHAMP: I was considered an artist in New York, and I accepted it; they knew I was working on my "Glass," I wasn't hiding it; people came to see me at home.

CABANNE: In 1918, you left for Buenos Aires.

DUCHAMP: Yes, I left for a neutral country. You know, since 1917 America had been in the war, and I had left France basically for lack of militarism. For lack of patriotism, if you wish.

CABANNE: And you had fallen into a worse patriotism!

DUCHAMP: I had fallen into American patriotism, which certainly was worse, but before leaving the United States I had to ask for permission, because even there I was classified for military duty. There were various categories, A, B, C, D, E, F, and F was foreigners, who would have been called up in an extreme emergency. I was F, and that's why I had to ask permission to leave for Buenos Aires; they were very nice about it and gave me permission for six months, and I left, in June–July 1918, to find a neutral country called Argentina.

CABANNE: Carrying along what you called "voyage sculptures" . . .

DUCHAMP: Yes, the voyage sculptures were really two things. One was the small "Glass," which is now in the Museum of Modern Art in New York, and which is broken. It's called "To Be Looked At with One Eye, Close to, for Almost an Hour"—this sentence was added to complicate things in a literary way—and then there were some rubber objects.

CABANNE: Actually they were pieces of rubber, of various dimensions and different colors, to be hung from the ceiling. . . .

DUCHAMP: Naturally, they took up a whole room. Generally, they were pieces of rubber shower caps, which I cut up and glued together and which had no special shape. At the end of each piece there were strings that one attached to the four corners of the room. Then, when one came in the room, one couldn't walk around, because of the strings! The length of the strings could be varied; the form was *ad libitum*.

That's what interested me. This game lasted three or four years, but the rubber rotted, and it disappeared.

CABANNE: Before leaving for Buenos Aires, you did a canvas, your first in five years, for Katherine Dreier, called "*Tu m*'." It was to be your last painting. A note in the "Green Box" specifies that you were much preoccupied with the problem of shadows. . . .

DUCHAMP: In that painting, I executed the cast shadow of the bicycle wheel, the cast shadow of the hatrack, which is above, and then also the cast shadow of a corkscrew. I had found a sort of projector which made shadows rather well enough, and I projected each shadow, which I traced by hand, onto the canvas. Also, right in the middle, I put a hand painted by a sign painter, and I had the good fellow sign it.

It was a sort of résumé of things I had made earlier, since the title made no sense. You can add whatever verb you want, as long as it begins with a vowel, after "*Tu m*' . . ."

CABANNE: Did you sell Arensberg the "Large Glass" before it was finished so you could get money to live on?

DUCHAMP: I didn't sell it, strictly speaking, because I never touched Arensberg's money. He just paid my rent for two years. And then he sold it to Katherine Dreier.

CABANNE: But didn't it belong to him?

DUCHAMP: Yes. It was understood that it belonged to him, and that he would settle with me by paying my rent monthly. He sold it for two thousand dollars, I think, which wasn't much at the time—or even now—since it wasn't finished; I still worked on it a lot, until 1923.

CABANNE: Every time you mention one of your works which has been sold, I have the impression that you never touched a dollar!

DUCHAMP: I never touched money, when that happened. . . .

CABANNE: What did you live on then?

DUCHAMP: I have no idea. I gave some French lessons, I sold a few paintings, the "Sonata," for example, one after another. . . .

CABANNE: Old paintings?

DUCHAMP: Old paintings. I even had the other "Glass" sent from Paris, the half-circle "Glass"; I sold it to Arensberg, too.

CABANNE: So basically it was your past that kept you alive.

DUCHAMP: Fortunately. I happened to make a little at that time. When one is young, one doesn't know how he lives. I didn't have a wife, a child, any "baggage," you see. People were always asking me how I lived, but one never knows, one gets along. Life goes on just the same. Certain people helped me. I never borrowed much money, except for some small amounts from time to time.

CABANNE: Notice that, back then, artists weren't ashamed of being supported.

DUCHAMP: One knew very well that there were people who made money and who understood that there were others, called artists or even craftsmen, who couldn't make a living. So they helped. Helping artists was a virtue for rich people. It was a monarchical concept—every period before democracy has done it—to protect painters, to protect the arts, etc.

CABANNE: You lived in Buenos Aires for nine months, and it was during this stay that you learned of Duchamp-Villon's death, and of Apollinaire's.

DUCHAMP: Apollinaire's was in November 1918, and my brother Raymond's was, I think, earlier, around July 1918.[3] From that moment on, I wanted to go back to France. I tried to find a boat, etc. . . . My brother's death hit me hard. I knew he was very sick, but one never knows how sick. It was called blood poisoning; it lasted for two years, going from abscess to abscess, and it finished in uremia. But I wasn't briefed on the details. He was in Cannes, there was the war, and we didn't correspond much.

So, I came back in 1918.

CABANNE: No, you came back in July 1919.

DUCHAMP: Yes, that's right, I came back a long time afterward.

CABANNE: But before coming back, you learned of the marriage of your sister Suzanne to Jean Crotti, and you sent him what you called the "Unhappy Readymade."

DUCHAMP: Yes. It was a geometry book, which he had to hang by strings on the balcony of his apartment in the rue Condamine; the wind had to go through the book, choose its own problems, turn and tear out the pages. Suzanne did a small painting of it, "Marcel's Unhappy Readymade." That's all that's left, since the wind tore it up. It amused me to bring the idea of happy and unhappy into readymades, and then the rain, the wind, the pages flying, it was an amusing idea. . . .

CABANNE: In any case, it was very symbolic for a marriage.

DUCHAMP: I never even thought of that.

CABANNE: You must have found Paris very changed?

DUCHAMP: Very difficult, very funny, very curious. I came via England—I don't remember if I saw my sister in London—I always arrived in Paris that way; I had Picabia's address, rue Emile-Augier, and it was the first thing I looked for, in Montmartre, or the seventeenth district. He wasn't there, it was hot, I was a sad sack, the streets were rather

[3] Actually, October 1918. [Ed.]

deserted, I had a hell of a time finding Picabia in his rue Emile-Augier. I knew him when he lived on the Avenue Charles-Floquet, in the Champ-de-Mars houses, which were new at that time.

CABANNE: Who were the first people you saw when you got back?

DUCHAMP: Mostly the ones I met through Picabia, because he had a literary salon, and he received the whole Cocteau bunch, etc. . . . One saw everyone there. Tzara came a little after I did, I think, I'm not sure. . . . Also there was Ribemont-Dessaignes, Pierre de Massot, Jacques Rigaud, etc. Rigaud was very sympathetic, he was very free and easy. He was Dada, if you like. It was then that I met Aragon too, on the boulevards, across from the Opera.

CABANNE: For you, Rigaud represented the young, postwar generation. His manner, his turn of mind, was rather near yours. . . .

DUCHAMP: We had a great sympathy for each other. Rigaud had none of Breton's strictness, that sort of desire to arrange everything into theories and formulas. Things were much gayer with him than with the others, who, in their enterprise of destruction, were very systematic.

CABANNE: What did you stand for, for the young people of that epoch?

DUCHAMP: Well, I don't know. I was ten years older, that's very important. Since I was ten years older, and Picabia was twelve or thirteen, we were the old men. Still, in the eyes of the young people, we represented a revolutionary element. Which we already were among the Cubists, who in 1912–13 didn't approve of us very much. We had, Picabia and I, gone through it with a certain freedom, without stepping on it, you see. I'm sure that's what they liked. They found that we represented the spirit that they, themselves, wanted to represent, and they were drawn to us.

CABANNE: You certainly had a notion of adventure too, which must have touched them. Your adventure in New York.

DUCHAMP: Yes, obviously, we had made something a little different from the other painters, from the practical point of view, from the point of view of the movement of words, etc. That's why there was an immediate exchange and correspondence, friendship.

CABANNE: And then, your "Mona Lisa" scandal had very clearly set a tone of revolt.

DUCHAMP: That was in 1919. . . .

CABANNE: Just before leaving for the United States again.

DUCHAMP: October 1919. But what did I do with that "Mona Lisa?" Nothing. I drew a moustache and a beard, that's all. I didn't show it anywhere.

CABANNE: Your friends didn't know about it?

DUCHAMP: Breton probably saw it at that time. The things I was doing, three or four more, I took to Picabia's—Breton saw them there.

CABANNE: I think the "Mona Lisa" was at Picabia's. He reproduced it in *391*, in March 1920.

DUCHAMP: That's not exactly the way it happened. I had brought my "Mona Lisa" over to pack it in my bag, and Picabia had taken the opportunity to put it first in *391*; he reproduced it himself by putting on a moustache, but forgetting the goatee. That made the difference. Picabia's "Mona Lisa" is often reproduced as being mine.

He called it "Dada Picture by Marcel Duchamp."

Another time, Picabia did a cover for *391* with the portrait of Georges Carpentier, the boxer; he and I were as much alike as two drops of water, which is why it was amusing. It was a composite portrait of Georges Carpentier and me.

CABANNE: Do the letters "L.H.O.O.Q." have a significance other than pure humor?

DUCHAMP: No, the only meaning was to read them phonetically.

CABANNE: It was just a phonetic game?[4]

DUCHAMP: Exactly. I really like this kind of game, because I find that you can do a lot of them. By simply reading the letters in French, even in any language, some astonishing things happen. Reading the letters is very amusing. It's the same thing for the Tzanck check. I asked him how much I owed, and then did the check entirely by hand. I took a long time doing the little letters, to do something which would look printed—it wasn't a small check.[5] And I bought it back twenty years later, for a lot more than it says it's worth! Afterward I gave it to Matta, unless I sold it to him. I no longer remember. Money was always over my head!

CABANNE: So you return to New York at the end of 1919, or the beginning of 1920, bringing with you the "Mona Lisa," and at the same time a bulb of "Paris Air."

DUCHAMP: Yes, that was amusing. It was a glass bulb a few centimeters high. "Physiological serum" was printed on the label. I'd brought it to Arensberg, as a souvenir from Paris.

CABANNE: It was then you finished a "thing," as you say, completely new for you, a machine—this time a real one—called "Precision Optics."

DUCHAMP: That was in fact one of the first "things" I made after I got back to New York. A series of five plates of glass on which I had traced

[4] A dirty pun, when the French letters are said aloud. [Ed.]
[5] Made out for one hundred and fifteen dollars, to be precise; it was a fake check, designed and printed by Duchamp, for his dentist. [Ed.]

black and white lines turning on a metal axle. Each plate was larger than the next, and when you looked at it from a certain point, it all fell together and made up a single pattern. While the motor was running, the lines gave the effect of continuous black and white circles, very hazy, as you can imagine.

Man Ray and I worked on the motor in the ground floor apartment I had then on West Seventy-third Street. We just missed being seriously hurt. We had an idiotic motor which picked up speed rapidly—you couldn't control it—it broke one of the glass plates, which flew into pieces. We had to start all over.

Four years later, I did the same thing for Jacques Doucet, a half-sphere with spirals, which took off from the same idea. I even did some research on optics, which disappeared, black and white lines—I don't know what they were supposed to do, exactly. I can't explain it to you. I no longer remember. I did only the drawings, and they've disappeared.

CABANNE: You were moving from antiartist to proengineer.

DUCHAMP: Yes . . . and, a cheap engineer!

CABANNE: Let's say "technician."

DUCHAMP: Everything I did as an engineer was with motors I bought. The idea of movement was what preoccupied me.

And then even so I was finishing work on my "Glass." I had taken it to a factory to have the right corner silvered, to a place where the "Oculist Witnesses" are. These witnesses were optical charts, for oculists, three sort of round, superimposed shapes which I copied. To copy them, I had to have the "Glass" silvered, then transfer the drawing, and scratch away the rest. That took at least six months, because it was very tiny and demanded high precision. It was precision optics, in short.

CABANNE: Every time you made a new experiment, you integrated it into the "Large Glass." The "Large Glass" represented the successive sum of your experiments for eight years.

DUCHAMP: That's exactly right.

CABANNE: Rrose Sélavy was born in 1920, I think.

DUCHAMP: In effect, I wanted to change my identity, and the first idea that came to me was to take a Jewish name. I was Catholic, and it was a change to go from one religion to another! I didn't find a Jewish name that I especially liked, or that tempted me, and suddenly I had an idea: why not change sex? It was much simpler. So the name Rrose Sélavy came from that. Nowadays, this may be all very well—names change with the times—but Rrose was an awful name in 1920. The double R comes from Picabia's painting, you know, the "*Œil cacodylate*,"

which is at the Boeuf sur le Toit cabaret; I don't know if it's been sold—it's the one Picabia asked all his friends to sign. I don't remember how I signed it—it was photographed, so someone knows. I think I put *"Pi Qu'habilla Rrose Sélavy"*—the word "arrose" demands two R's, so I was attracted to the second R—*"Pi Qu'habilla Rrose Sélavy."*[6]

All of this was word play.

CABANNE: You went so far in your sex change as to have yourself photographed dressed as a woman.

DUCHAMP: It was Man Ray who did the photograph. At the 1938 Surrealist exhibition at the Wildenstein Gallery in Paris, each of us had his own mannekin; me, I had a woman mannekin, to which I had given my clothes; it was Rrose Sélavy herself.

CABANNE: At that time in 1920 and 1921, what was important for you?

DUCHAMP: Nothing. Yes, my "Glass." That held me until 1923, the only thing I was interested in, and I even regret not finishing it, but it became so monotonous, it was a transcription, and toward the end there was no invention. So it just fizzled out. I left for Europe in 1923, and when I came back three years later, the "Glass" was broken. . . .

CABANNE: Why did you refuse to take part in the Dada Salon of 1920?

DUCHAMP: Only so I could make a pun. My telegram, *"Peau de balle,"* was spelled *"Pode bal."*[7] It was addressed to Crotti. Well, what in the world could I send them? I didn't have anything especially interesting to send, I didn't even know what Dada was.

CABANNE: When you returned to New York, in 1920, I think, you did a readymade, "Fresh Widow," and the year after that, "Why Not Sneeze?"

DUCHAMP: "Why Not Sneeze?" was ordered by Katherine Dreier's sister, who wanted something of mine. Since I didn't want to do a painting, in the usual sense of the word, I told her, "Fine, but I'll do whatever comes into my head." I took some little pieces of marble in the form of sugar cubes, a thermometer, and a cuttlebone, shut them up in a little bird cage, and painted the whole thing white. I sold it to her for three hundred dollars. I made some money there! The poor woman couldn't accept it, she was very, very upset by it. She sold it to her sister Katherine, who, after a while, couldn't stand it either. She gave it to Arensberg, for the same price. I'm trying to say that no one really liked it. Still, I was very happy to have made it; I had to do the sugar cubes in marble; the whole operation wasn't exactly ready-made, except for the cage. As for the "Fresh Widow". . . .

[6] In fact, it reads *"en 6 qu'habillarrose Selavy."* [Trans.]
[7] Roughly, "Balls to you." [Trans.]

CABANNE: It was another pun. Fresh, French, Widow, window.

DUCHAMP: Yes, "fresh" widow, meaning "smart."

CABANNE: Merry widow!

DUCHAMP: If you like. The combination amused me, with French window. I had the window made by a carpenter in New York. The little panes are covered with black leather, and would have to be shined every morning like a pair of shoes in order to shine like real panes. All these things had the same spirit.

CABANNE: Robert Lebel said that, at that moment, you "had reached the limit of the unaesthetic, the useless, and the unjustifiable."

DUCHAMP: In any case, it's very pleasing as a formula. Did he write that in his book? Well, it's very nice—I congratulate him! You know, people have poor memories.

CABANNE: Not you. You have a fantastic memory.

DUCHAMP: In general, memory of the remote past is quite exact.

CABANNE: In 1921, you came back to Paris for eight months, until 1922. . . .

DUCHAMP: I couldn't stay in New York more than six months at a time, because I had a tourist visa, or something like that. So after six months, one had to ask for an extension. I preferred to leave. And come back later.

It was in July 1921 that Man Ray arrived in Paris. I was living in the rue de La Condamine, and I had him move into a maid's room next door. He made his debut brilliantly by meeting Paul Poiret, the couturier, who took a fancy to him. Poiret had him do fashion photography, so Man Ray earned something right away with his photographs.

CABANNE: In October 1922, Breton published an article on you in *Littérature*, a very eulogistic one which created a lot of excitement. . . .

DUCHAMP: Yes. At that time there was a very real exchange between us. He was a very pleasant friend. He had enormous weight in the literary world, and it was odd that he was so far ahead of people like Aragon and Eluard, who were only his lieutenants. I don't remember where we saw each other—there have been so many cafés in our lives—I no longer remember where we got together. From 1923 to 1926, I lived in a small room in the Hôtel Istria, rue Campagne-Première. At first I had a studio in the rue Froidevaux, but it was so cold. . . . It was so awful in that hotel; Man Ray, who had also left the rue de La Condamine, lived on the same floor. He had his studio in the big mansion next door, at the end of the rue Campagne-Première. From 1922–23 on, he worked there and slept at the Istria. I stayed there all the time, because I wasn't working on anything.

CABANNE: Had you left the "Large Glass" in New York?

DUCHAMP: Yes. And when I came back three years later, I didn't go back

to it. In the meantime, it had been broken. . . . But that wasn't what kept me from working on it, it was the fact that I wasn't there. You know how it is to continue something after eight years. It was monotonous. . . . You have to be very strong. I wasn't bothered by it, there were simply other things happening in my life then. When I returned to New York, I did that thing for Doucet, that optical turning thing, in 1924–25, and the little cinema.[8]

CABANNE: Had you already made the decision to stop painting?

DUCHAMP: I never made it; it came by itself, since the "Glass" wasn't a painting; there was lots of lead, a lot of other things. It was far from the traditional idea of the painter, with his brush, his palette, his turpentine, an idea which had already disappeared from my life.

CABANNE: Did this break ever bother you?

DUCHAMP: No, never.

CABANNE: And you've never had a longing to paint since then?

DUCHAMP: No, because when I go to a museum, I don't have a sort of stupefaction, astonishment, or curiosity in front of a picture. Never. I'm talking about the old masters, the old things. . . . I was really defrocked, in the religious sense of the word. But without doing it voluntarily. All that disgusted me.

CABANNE: You never touched a brush or a pencil?

DUCHAMP: No. It had no interest for me. It was a lack of attraction, a lack of interest.

I think painting dies, you understand. After forty or fifty years a picture dies, because its freshness disappears. Sculpture also dies. This is my own little hobbyhorse, which no one accepts, but I don't mind. I think a picture dies after a few years like the man who painted it. Afterward it's called the history of art. There's a huge difference between a Monet today, which is black as anything, and a Monet sixty or eighty years ago, when it was brilliant, when it was made. Now it has entered into history—it's accepted as that, and anyway that's fine, because that has nothing to do with what it is. Men are mortal, pictures too.

The history of art is something very different from aesthetics. For me, the history of art is what remains of an epoch in a museum, but it's not necessarily the best of that epoch, and fundamentally it's probably even the expression of the mediocrity of the epoch, because the beautiful things have disappeared—the public didn't want to keep them. But this is philosophy. . . .

[8] *Anemic Cinema.* Ten disks of images alternating with nine inscribed disks, made with Man Ray and Marc Allegret. Anemic is an anagram of cinema. [P.C.]

CABANNE: What importance did your meeting with Mary Reynolds have for you?

DUCHAMP: That of a great friendship. Mary was a very independent woman; she loved the Boeuf sur le Toit night club—she went there almost every night. It was a very agreeable liaison indeed. . . .

CABANNE: Did you know her in New York?

DUCHAMP: Yes, but very little. I really met her in Paris, when she came in 1923. She was living near the Eiffel Tower; I went to see her often. But I had my hotel room. It was a true liaison, over many, many years, and very agreeable; but we weren't glued together, in the "married" sense of the word.

CABANNE: At that period, you took part in René Clair's *Entr'acte*, with Man Ray, Picabia, and Erik Satie. Then in a ballet put on by Rolf de Maré. This was eclecticism. . . .

DUCHAMP: If you wish. *Entr'acte*, as its name says, was shown during the intermission at a performance of the Swedish Ballet. The one I was in was *Relâche*, by Picabia and Satie. There was only one performance. I played Adam naked, with a fake beard and a fig leaf. Eve was a young Russian girl, Bronja, who was also completely nude. René Clair was above, in the rafters, projecting the light down on us, and it was there he fell in love with her. He married her a few months later. You see, I'm a "matchmaker," a maker of marriages! In *Entr'acte* there was a scene on the roofs over the Champs-Élysées, in which I'm playing chess with Man Ray. Picabia comes in with a nozzle from a hose and washes everything away. It was very Dada, you see.

CABANNE: What were you looking for in movies and in the theater?

DUCHAMP: The movies especially amused me because of their optical side. Instead of making a machine which would turn, as I had done in New York, I said to myself, "Why not turn the film?" That would be a lot simpler. I wasn't interested in making movies as such; it was simply a more practical way of achieving my optical results. When people say that I've made movies, I answer that, no, I haven't, that it was a convenient method—I'm particularly sure of that now—of arriving at what I wanted. Furthermore, the movies were fun. The work went millimeter by millimeter, because there weren't any highly perfected machines. There was a little circle, with the millimeters marked off; we filmed image by image. It took two weeks. The equipment wasn't able to take the scene at any specific speed—it was a mess—and since it was filming rather quickly, it created a curious optical effect. So we were therefore obliged to abandon mechanical means, and make everything ourselves. A return to the hand, so to speak.

I Like Breathing Better than Working

PIERRE CABANNE: You have said, "A painting that doesn't shock isn't worth painting."

MARCEL DUCHAMP: That's a little rash, but fair enough. In the production of any genius, great painter or great artist, there are really only four or five things that really count in his life. The rest is just everyday filler. Generally, these four or five things shocked when they first appeared. Whether it's "Les Demoiselles d'Avignon," or "La Grande Jatte," they're always shocking works. In this sense, I do not feel like going to admire every Renoir, or even all of Seurat. . . . Still, I like Seurat a lot— that's another question. I dream of rarity, what otherwise could be known as a superior aesthetic. People like Rembrandt or Cimabue worked every day for forty or fifty years, and it is we, posterity, who have decided that this was very good because it was painted by Cimabue or Rembrandt. Any little bit of trash by Cimabue is still very much admired. It's a piece of trash next to three or four things he made which I don't know about anyway, but which exist. I apply this rule to all artists.

CABANNE: You have also said that the artist is unaware of the real significance of his work and that the spectator should always participate in supplementing the creation by interpreting it.

DUCHAMP: Exactly. Because I consider, in effect, that if someone, any genius, were living in the heart of Africa and doing extraordinary paintings every day, without anyone's seeing them, he wouldn't exist.

To put it another way, the artist exists only if he is known. Consequently, one can envisage the existence of a hundred thousand geniuses who are suicides, who kill themselves, who disappear, because they didn't know what to do to make themselves known, to push themselves, and to become famous.

I believe very strongly in the "medium" aspect of the artist.[1] The artist makes something, then one day, he is recognized by the intervention of the public, of the spectator; so later he goes on to posterity. You can't stop that, because, in brief, it's a product of two poles—there's the pole of the one who makes the work, and the pole of the one who looks at it. I give the latter as much importance as the one who makes it.

Naturally, no artist accepts this interpretation. But when you get right down to it, what is an artist? As much as the furniture maker, say Boulle, he's the man who owns a "Boulle." A work is also made of the admiration we bring to it.

African wooden spoons were nothing at the time when they were made, they were simply functional; later they became beautiful things, "works of art."

Don't you think the spectator's role is important?

CABANNE: Certainly, but I don't completely agree with you. Take, for example, "Les Demoiselles d'Avignon." The public didn't see it until twenty or thirty years after it was done, but still it was something very important for the few people Picasso showed it to.

DUCHAMP: Yes, but there are perhaps other works which were important at the beginning, and which have disappeared. I'm thinking of Girieud, whom I liked a lot.

CABANNE: Metzinger, too.

DUCHAMP: Yes. The pruning is done on a grand scale. In fifty years, well, well!

CABANNE: Are you thinking that a man like Girieud made an unknown masterpiece?

DUCHAMP: No. Not at all. Properly, any masterpiece is called that by the spectator as a last resort. It is the onlooker who makes the museum, who provides the elements of the museum. Is the museum the final form of comprehension, of judgment?

The word "judgment" is a terrible thing, too. It's so problematical, so weak. That a society decides to accept certain works, and out of them make a Louvre, which lasts a few centuries. But to talk about truth and real, absolute judgment—I don't believe in it at all.

[1] I.e., the artist as a medium. [Ed.]

CABANNE: Do you go to museums?

DUCHAMP: Almost never. I haven't been to the Louvre for twenty years. It doesn't interest me, because I have these doubts about the value of the judgments which decided that all these pictures should be presented to the Louvre, instead of others which weren't even considered, and which might have been there. So fundamentally we content ourselves with the opinion which says that there exists a fleeting infatuation, a style based on a momentary taste; this momentary taste disappears, and, despite everything, certain things still remain. This is not a very good explanation, nor does it necessarily hold up.

CABANNE: Still, you accepted the idea that *your* entire work would be in a museum?

DUCHAMP: I accepted because there are practical things in life that one can't stop. I wasn't going to refuse. I could have torn them up or broken them; that would have been an idiotic gesture.

CABANNE: You could have asked that they be in a nonpublic place.

DUCHAMP: No. That would have been insanely pretentious.

CABANNE: Being protected yourself, you could have wanted to protect your work. . . .

DUCHAMP: Certainly. I'm slightly embarrassed by the publicity aspect which things take on, because of that society of onlookers who force them to re-enter a normal current, or, at least, what is called normal. The group of onlookers is a lot stronger than the group of painters. They oblige you to do specific things. To refuse would be ridiculous. To refuse the Nobel Prize is ridiculous.

CABANNE: Would you accept going into the Institute of Art?

DUCHAMP: No, my God, no! I couldn't! Besides, for a painter that doesn't mean much! Aren't they all literary people, I think, the members of the Institute?

CABANNE: No. There are painters too. Rather worldly ones.

DUCHAMP: The academic sort?

CABANNE: Yes.

DUCHAMP: No. I wouldn't sign a request to belong to the Institute. Anyway, it surely won't be proposed to me.

CABANNE: Who are the old masters you like?

DUCHAMP: I don't know them very well, really. I have appreciated Piero de Cosimo. . . .

CABANNE: You like the medieval primitives?

DUCHAMP: The primitives, yes. After that, there are some things I find hard to accept, like Raphael. Because one senses that they've been put there, and that classes of society have kept them there.

CABANNE: In 1924, you took part in a chess tournament in Nice. From there you went to Italy. Why did you go there?

DUCHAMP: To see a friend.

CABANNE: You didn't go for artistic reasons?

DUCHAMP: No. None at all. I spent a day in Florence. I didn't see anything. I also spent two or three weeks around Rome, in a district where there were several artists, but it wasn't at all to work or to look at pictures. No, I really haven't seen much of Italy. I went to Florence a little more seriously, I think, three years ago. I finally went to the Uffizi Gallery. Obviously, there's a lot there, but I really can't enjoy beginning an "artistic" education, in the old sense of the word! That doesn't interest me; I don't know why; I can't explain it.

CABANNE: When you were young, didn't you ever experience the desire to be artistically cultured?

DUCHAMP: Maybe, but it was a very mediocre desire. I would have wanted to work, but deep down I'm enormously lazy. I like living, breathing, better than working. I don't think that the work I've done can have any social importance whatsoever in the future. Therefore, if you wish, my art would be that of living: each second, each breath is a work which is inscribed nowhere, which is neither visual nor cerebral. It's a sort of constant euphoria.

CABANNE: That's what Roché said. Your best work has been the use of your time.

DUCHAMP: That's right. I really think that's right.

CABANNE: Toward 1924–25, you made some new projects for optical machines.

DUCHAMP: Yes. At that time, I felt a small attraction toward the optical. Without really ever calling it that. I made a little thing that turned, that visually gave a corkscrew effect, and this attracted me; it was amusing. At first I made it with spirals . . . not even spirals—they were off-center circles which, inscribed one inside the other, formed a spiral, but not in the geometric sense; rather in the visual effect. I was busy with that from 1921 to 1925.

Later, using the same procedure, I found a way of getting objects in relief.[2] Thanks to an offhand perspective, that is, as seen from below or from the ceiling, you got a thing which, in concentric circles, forms the image of a real object, like a soft-boiled egg, like a fish turning around in a fishbowl; you see the fishbowl in three dimensions. What interested me most was that it was a scientific phenomenon which

[2] "Rotorelief." [Ed.]

existed in another way than when I had found it. I saw an optician at that time who told me, "That thing is used to restore sight to one-eyed people, or at least the impression of the third dimension." Because, it seems, they lose it.

At that moment my experiments interested a few specialists. Me, it amused me.

CABANNE: But it's very retinal!

DUCHAMP: Yes, but it's something you can't do for fifteen, or even ten years. After a while, it's finished.

CABANNE: You didn't do much with it.

DUCHAMP: No. Only in 1934. Then it was finished.

CABANNE: Some time before that, you had discovered a new activity. A rather unexpected one, moreover. Breaking your detachment, you began buying and selling paintings.

DUCHAMP: That was with Picabia. We agreed that I would help him with his auction at the Hôtel Drouot. A fictitious auction, however, since the proceeds were for him. But obviously he didn't want to be mixed up in it, because he couldn't sell his paintings at the Salle Drouot under the title "Sale of Picabias by Picabia!" It was simply to avoid the bad effect that would have had. It was an amusing experience. It was all very important for him, because, until then, no one had had the idea of showing Picabias to the public, let alone selling them, giving them a commercial value. . . .

I bought a few little things then. I don't remember what, any more. . . .

CABANNE: You bought back your own works, for Arensberg.

DUCHAMP: There was the Quinn auction, in New York.[3] Quinn died in 1925, and his collection was auctioned off; that's where I bought the Brancusis.

CABANNE: Then you organized a Brancusi show in New York.

DUCHAMP: To sell them again, at once. It was Brancusi who had asked us, Roché and me, to buy back his works. He was afraid that if they were put up for public sale, they would make only two or three hundred dollars apiece, when he had already sold them for a lot more. We arranged with Mrs. Rumsey, a great friend of Brancusi, to buy back from the Brummer Gallery twenty-two Brancusis for eight thousand dollars, which was very cheap, even at that time.

We split three ways. We reimbursed Mrs. Rumsey for what she had put up, and then we—Roché and I—had about fifteen Brancusis, which we divided. This commercial aspect of my life made me a living.

[3] John Quinn, the great New York lawyer, had an important collection. He was one of the first admirers of Brancusi. [P.C.]

When I needed money, I'd go to Roché and say, "I have a small Brancusi for sale; how much will you give me?" Because at that moment the price was very low. That lasted for fifteen or twenty years.

CABANNE: The progressive rise of Brancusi prices helped you.

DUCHAMP: Yes, but at the time it wasn't at all foreseeable.

CABANNE: Wasn't your commercial activity in contradiction to your attitude?

DUCHAMP: No. One must live. It was simply because I didn't have enough money. One must do something to eat. Eating, always eating, and painting for the sake of painting, are two different things. Both can certainly be done simultaneously, without one destroying the other. And then, I didn't attach much importance to selling them. I bought back one of my paintings, which was also in the Quinn sale, directly from Brummer. Then I sold it, a year or two later, to a fellow from Canada. This was amusing. It didn't require much work from me.

CABANNE: Because it was during this period that Arensberg decided to gather your works together, and to give them to the Philadelphia Museum. You helped him round them up.

DUCHAMP: Yes, that's right.

CABANNE: Fundamentally, was it a way of valorizing yourself?

DUCHAMP: No, no, absolutely not.

CABANNE: At least, you preferred that your works be assembled in a single place where they could be seen.

DUCHAMP: That is true. I had a certain love for what I was making, and this love was translated into that form.

CABANNE: Still your craftsman self.

DUCHAMP: I wanted the whole body of work to stay together. Moreover, I found that my works weren't numerous enough to make a profit painting after painting. And, above all, I wanted as much as possible not to make money. Generally the paintings I sold were my old ones. For instance, when I left for America there were a lot of paintings that stayed in France; I had them sent over and Arensberg bought them. There were also things that belonged to other people. My sister had a portrait of my father, which she wanted to keep. She had to be persuaded to sell it to Arensberg.

CABANNE: You've never dreamed of saving something for yourself?

DUCHAMP: Yes. An amusing thing. In New York, I had a "Glass" which I had given to Roché in 1915.[4] It was broken. I had put it between two other glass panes, in a wooden case, and Roché, then on his way back to France, took it with him.

PAGE 74 [4] The "Nine Malic Moulds." [P.C.

Forty years later, my wife wanted to buy it. We had to pay through the nose to have it back! It's amusing. I wasn't at all mad at Roché, but the thing that I had given him he sold back to my wife at an astronomical price. Because it was she who bought it back, not me!

CABANNE: But wasn't Roché very rich?

DUCHAMP: He had made a fortune in paintings. Or from the commissions he got on the Brancusis. He was a charming man, who found it completely natural that one should pay. Whether it be me or someone else, it was all the same.

CABANNE: You, too, had a rather curious idea of how to make money. You made some insignias bearing the four letters D A D A, which you wanted to sell, I think, for a dollar.

DUCHAMP: It was amusing.

CABANNE: It was a sort of amulet, a fetish.

DUCHAMP: It wasn't to make money. It wasn't at all lucrative. Besides, I never made any of the insignia.

CABANNE: Never?

DUCHAMP: No.

CABANNE: You wrote to Tzara that the fact of buying it would "consecrate" the Dada buyer. It would also protect him from certain illnesses, certain vexations. Something like "the little pink pills for everything."

DUCHAMP: Yes. At a certain point, Breton had had the idea of opening up a Surrealist office, to give people advice. It's in the same spirit.

CABANNE: Nineteen twenty-six is the year that the "Large Glass" was cracked.

DUCHAMP: While I was gone, it was shown in an international exhibition at the Brooklyn Museum. The people who sent it back to Katherine Dreier, to whom it belonged, weren't professionals; they were careless. They put the two glasses one on top of the other, in a truck, flat in a box, but more or less well packed, without knowing if there were glass or marmalade inside. And after forty miles, it was marmalade. The only curious thing was that the two pieces were one on top of the other, and the cracks on each were in the same places.

CABANNE: The cracks follow the direction of the network of stoppages, it's astonishing all the same.

DUCHAMP: Exactly, and in the same sense. It constitutes a symmetry which seems voluntary; but that wasn't the case at all.

CABANNE: When one sees the "Large Glass," one doesn't imagine it intact at all.

DUCHAMP: No. It's a lot better with the breaks, a hundred times better. It's the destiny of things.

CABANNE: The intervention of chance that you count on so often.

DUCHAMP: I respect it; I have ended up loving it.[5]

CABANNE: You came to spend eight years in Paris, from 1927 to 1935. In 1927, a rather unexpected event took place again in your life, that is, your marriage. Which lasted six months.

DUCHAMP: Yes, with a Miss Sarrazin-Levassor, a very nice girl. This marriage was half made by Picabia, who knew the family. We were married the way one is usually married, but it didn't take, because I saw that marriage was as boring as anything. I was really much more of a bachelor than I thought. So, after six months, my wife very kindly agreed to a divorce. She had no child, and asked for no alimony, so it happened as simply as possible. Then she remarried and had children.

CABANNE: Michel Carrouges has noted, particularly in the "Large Glass," a "negation of woman. . . ."

DUCHAMP: It's above all a negation of woman in the social sense of the word, that is to say, the woman-wife, the mother, the children, etc. I carefully avoided all that, until I was sixty-seven. Then I married a woman who, because of her age, couldn't have children. I personally never wanted to have any, simply to keep expenses down. That's what Carrouges must mean. One can have all the women one wants, one isn't obliged to marry them.

CABANNE: You protected yourself particularly against the family.

DUCHAMP: That's it. The family that forces you to abandon your real ideas, to swap them for things it believes in, society and all that paraphernalia!

CABANNE: At that time, you took an active part in the Surrealist demonstrations. You defended de Chirico against the anathema of Breton and his friends, maintaining that, in the end, it is posterity who will decide. That preoccupation with posterity is a bit strange for you.

DUCHAMP: No, it isn't. Posterity is a form of the spectator.

CABANNE: The "posthumous" spectator, if one can say that.

DUCHAMP: Certainly. It's the posthumous spectator, because the contemporary spectator is worthless, in my opinion. His is a minimum value compared to that of posterity, which, for example, allows some things to stay in the Louvre.

To get back to Breton: the way they condemned de Chirico after 1919 was so artificial that it rubbed me the wrong way. There had already been other rehabilitations, and I felt, "Wait for posterity."

CABANNE: What was your position vis-à-vis Surrealist painting?

[5] There is an etching by Duchamp showing the "Glass" unbroken, and another showing how it would have been, had he finished it. [Ed.]

DUCHAMP: Very good. But I didn't always like the way they adopted whatever came along, that is, abstraction. I'm not talking about the main painters, like Max Ernst, Magritte, Dali; I'm talking about the followers, around 1940. That was already an old Surrealism. . . . Fundamentally, the reason Surrealism survived is that it wasn't a school of painting. It isn't a school of visual art, like the others. It isn't an ordinary "ism," because it goes as far as philosophy, sociology, literature, etc.

CABANNE: It was a state of mind.

DUCHAMP: It's like Existentialism. There isn't any existential painting.

CABANNE: It's a question of behavior.

DUCHAMP: That's it.

CABANNE: Which Surrealist painters did you prefer?

DUCHAMP: All of them. Miró, Max Ernst, and de Chirico, whom I liked a lot too.

CABANNE: In these cases, you mean friendship particularly, not painting?

DUCHAMP: No, painting, too. I was very interested in the works of these painters, in the sense that one is influenced, moved. . . .

CABANNE: Still, there's a "retinal" part of Surrealism. Didn't this bother you?

DUCHAMP: No, because you have to know how to use it. With them, the ultimate intention is beyond that,[6] especially in the fantastic things.

CABANNE: It's more conceptual than visual.

DUCHAMP: Exactly. Please note that there doesn't have to be a lot of the conceptual for me to like something. What I don't like is the completely nonconceptual, which is purely retinal; that irritates me.

CABANNE: In 1932, you wrote a work on chess which became a classic, called "The Opposition and Sister Squares Are Reconciled." It's a marvelous Surrealist title.

DUCHAMP: The "opposition" is a system that allows you to do such-and-such a thing. The "sister squares" are the same thing as the opposition, but it's a more recent invention, which was given a different name. Naturally, the defenders of the old system were always wrangling with the defenders of the new one. I added "reconciled" because I had found a system that did away with the antithesis. But the end games in which it works would interest no chess player. That's the funny part. There are only three or four people in the world who have tried to do the same research as Halberstadt, who wrote the book with me, and myself. Even the chess champions don't read the book, since the


I Like Breathing Better than Working


[6] Max Ernst's most important essay is called "Beyond Painting." [Ed.]

problem it poses really only comes up once in a lifetime. They're end-game problems of possible games but so rare as to be nearly Utopian.

CABANNE: You always stayed in the conceptual domain.

DUCHAMP: Oh! Yes, completely. It was neither common nor utilitarian.

CABANNE: At that time, you were living at number 11 rue Larrey, where you invented a door that can be, at the same time, both open and closed. Does it still exist?

DUCHAMP: Yes, it does, but I detached it two years ago and sent it to the United States. Now it's part of the Mary Sisler collection. It was in the same state as I had left it, since Patrick Waldberg was living there. He had left the United States in 1946, and didn't have any place to stay in Paris. I gave him my studio, since I wasn't living there. His first wife, the sculptor Isabelle Waldberg, still lives there. I bought that door back for about twenty dollars, I think.

CABANNE: That's not expensive for a door!

DUCHAMP: It was so that the owner could have another one made, you see. Which she did, I think. I exhibited it last year, and it is now in London;[7] they have simply put up a life-size photo of it in color, which Schwarz had made for the show, and which is a very good one. It gives a perfect impression of a door, in *trompe-l'œil*!

CABANNE: You made the "Green Box" in Paris in 1934: three hundred examples, containing ninety-three photo-documents, drawings, and manuscript notes from the years 1911–15, reproduced in photographs, with twenty de luxe copies. Rrose Sélavy Editions, 18 rue de la Paix. It's yet another example of your constant preoccupation: to collect your work and to preserve it.

DUCHAMP: Yes. Everything I was doing demanded precision work over a long enough period; I found that it was worth the trouble to preserve it. I worked slowly; consequently, I attached to it an importance comparable to anything one takes great care with.

CABANNE: During that period, you seem to have been more concerned with preserving your work than with continuing it.

DUCHAMP: Yes, because I had already stopped making things.

CABANNE: Had you stopped absolutely?

DUCHAMP: Yes, but not absolutely. It had simply stopped. That's all.

CABANNE: Was it your natural laziness?

DUCHAMP: Yes! Then, since it wasn't a matter of an enormous *œuvre*, it was easy to make the "Box." And amusing. Still, it took me four

　　　[7] The Tate Gallery retrospective, 1966. [P.C.]

years to produce the documents, between 1934 and 1940. It was finished exactly at the moment the war began. I was going to the printer's every day. I did everything myself. It cost me very little.

CABANNE: You amaze me!

DUCHAMP: No. Even then, it wasn't expensive. I don't recall what fifty thousand francs meant at the time, but it didn't cost any more than that.[8]

CABANNE: In 1940, that was a lot.

DUCHAMP: Maybe. I kept track of how much it cost me. I had a lot of things done photographically on large paper; no, no, it didn't cost much.

CABANNE: Did you put the three hundred boxes together yourself?

DUCHAMP: They're not finished yet. There are a hundred left to make. The reproductions were printed in parcels of three hundred. You make a "Box." Then you take the reproductions, when they are wanted. . . .

CABANNE: One can order a "Box?"

DUCHAMP: Yes, if you wish. They're made twenty-five at a time. It takes almost a month to do a "Box" without rushing.

CABANNE: But who makes them?

DUCHAMP: Currently, a young lady in my family. Before, there were other people. The first twenty, which were the de luxe copies in which there was an original, I made myself.

CABANNE: When one wants a "Green Box," one orders one from you, and it is delivered in a month?

DUCHAMP: That's it. But there are two things—the "Green Box" and the "Box in Valise."

CABANNE: They are different; but the "Box in Valise" comes a little later.

DUCHAMP: It's from 1938 to '42. The "Green Box" is from '34.

CABANNE: What's the difference between the two?

DUCHAMP: One is green, as its name suggests, and inside it there are papers, all cut out in the shape in which I wrote them. I kept the shape of the original piece of paper. As for the "Box in Valise," I had to make the frame, the compartments, the drawers, etc. It was considerable work, in addition to the sixty-eight reproductions, you see.

CABANNE: There were three hundred examples of this also.

DUCHAMP: Exactly. I began the first edition of twenty copies in 1938, and it wasn't finished when I left for the United States in '42. I had to have it brought across the demarcation line in pieces. I went back and forth several times, with a cheese dealer's pass.

[8] About one hundred dollars. [Ed.]

There are about fifteen "Green Boxes" left, no more. I dole them out slowly, because I always want to have some on hand to sell before I die, while there are a hundred others remaining to be made.

CABANNE: You entered the "Rotoreliefs" in the Concours Lepine,[9] under the title of "benevolent technician." You were a little late in conforming to Apollinaire's famous phrase that had you "reconciling Art and the People." I believe the whole thing did not go well?

DUCHAMP: Very badly. I rented a stand, even hired a secretary, since I didn't want to stay there all day; people went along, bought a refrigerator, then saw the "Rotoreliefs," which didn't mean much to them. At the end of a month—because it lasted a month—I had sold one example. . . .

CABANNE: For thirty francs, I believe.

DUCHAMP: It was unbelievable! And it cost me a lot more than that.

CABANNE: In 1937, you exhibited in Paris.

DUCHAMP: Where was that?

CABANNE: At André Breton's art gallery, Gradiva. It was there you thought up a door. . . .

DUCHAMP: Oh! Yes. The door with the silhouette of a couple cut out of the windowpane.

CABANNE: And your first one-man show was at the Arts Club of Chicago, also in 1937, wasn't it?

DUCHAMP: I don't know exactly; I didn't go.

CABANNE: It was your only one-man show until then.

DUCHAMP: I had sent things to the Indépendants in 1908 or 1909, then to the Salon d'Automne, but I hadn't had a one-man show. I never did have one, until two years ago, in Pasadena, and then this year, 1966, in London.

CABANNE: Who persuaded you to have the show in Chicago?

DUCHAMP: I was asked and I said "yes." It wasn't a big show, there were ten things in all. This Arts Club organized little exhibitions from time to time. It wasn't a very big place. They asked me if I wanted to do it, and I accepted. It happens to a lot of artists, they're asked to exhibit! But it wasn't important, and I didn't even go to see my own exhibition.

CABANNE: From a certain number of the events in your life, one has the impression that you're only too happy to reply to a request.

DUCHAMP: Usually. I'm not what one would call an ambitious man who solicits. I don't like soliciting; in the first place, because it's tiring; and then generally it doesn't do any good. I don't expect anything. I don't

[9] An industrial exposition. [Ed.]

need anything. Soliciting is one of the forms of need, the consequence of a need. This doesn't exist for me, because fundamentally I have got along fine without producing anything for a long time now. I don't ascribe to the artist that sort of social role in which he feels obligated to make something, where he owes himself to the public. I have a horror of such considerations.

CABANNE: You did exactly the opposite by participating in the Surrealist Exhibition of 1938 in Paris.

DUCHAMP: It wasn't the same thing. I was part of a team, a group, and I gave advice. Two times.

CABANNE: The first time in 1938.

DUCHAMP: Yes, at the Wildenstein Gallery.

CABANNE: How did you, such an independent man, accept the Surrealist draft?

DUCHAMP: It wasn't a draft. I had been borrowed from the ordinary world by the Surrealists. They liked me a lot; Breton liked me a lot; we were very good together. They had a lot of confidence in the ideas I could bring to them, ideas which weren't antisurrealist, but which weren't always Surrealist, either.

In 1938, it was very amusing. I had had the idea of a central grotto, with twelve hundred sacks of coal hung over a coal grate. The grate was electric, but the insurance companies said no. We did it anyway, and then they accepted it. Besides, the sacks were empty.

CABANNE: There wasn't any coal inside?

DUCHAMP: There was coal dust. They were real sacks, which had been found in la Villette. There were papers inside, newspapers, which filled them out.

CABANNE: And these coal sacks were hung above a pond; it could have put out a fire!

DUCHAMP: It was Dali's pond.

CABANNE: At this exhibition you also invented the revolving doors. What were they exactly?

DUCHAMP: Doors that turned.

CABANNE: Like the "blount?"[10]

DUCHAMP: That's it. Revolving doors that were used to hang drawings and objects from. The coal grate, out in the middle, gave the only light. Man Ray had the idea of giving each visitor a flashlight, in case he wanted to see something.

CABANNE: Yes, but wasn't the flashlight supply exhausted after a few hours?

I Like Breathing Better than Working

[10] A French gadget for a revolving door. [Ed.]

DUCHAMP: Very quickly. That was really too bad. There was another amusing detail, the smell of coffee. In a corner, we had an electric plate on which coffee beans were roasting. It gave the whole room a marvelous smell; it was part of the exhibition. It was rather Surrealist, altogether.

CABANNE: Why did you leave for New York the night before the opening?

DUCHAMP: I had done what was necessary before, and I have a horror of openings. Exhibitions are frightful. . . .

CABANNE: Just the same, they have happened to you several times, and you went to London especially for your opening at the Tate Gallery.

DUCHAMP: Yes, I went to London expressly for that. I attended a dinner.

CABANNE: You've settled down.

DUCHAMP: I've settled down. I accept that.

CABANNE: You are resigned.

DUCHAMP: Oh! You think so?

CABANNE: In 1939, under the title "Rrose Sélavy," you published a collection of printed, modified readymades.

DUCHAMP: Who did it? I don't remember.

CABANNE: Guy Lévis-Mano's place.

DUCHAMP: Oh! That's something else. Those were puns; I don't know why they were called readymades. Printed, modified. Yes, in effect. I believe I had called them "kicks in all genres." I don't recall the exact title any more. I had one of them the other day. It's a very pretty one, too. At that time I also did a cover for André Breton: a door-window with bricks. That was also done by Lévis-Mano. I used all that in my "Box in Valise." I had line cuts made, and ran off four hundred extra copies for myself. It was a way of economizing a bit.

CABANNE: Your "*poils et coups de pied en tous genres*"[11]—that's the exact title—were spoonerisms. They're part of the "Box in Valise," recopied on music paper.

DUCHAMP: I also used them in the "Optical Discs" and the "Rotoreliefs." Several were published.

CABANNE: What were you living on at the time?

DUCHAMP: I have no idea. Absolutely no idea.

CABANNE: You always give the same answer!

DUCHAMP: But I really have no idea. And you don't know either!

CABANNE: Oh! Me, of course!

DUCHAMP: No one knows how I lived. Actually, your question suggests no exact answer. I could tell you that I sold Brancusis, and it would

[11] I.e., "hairs and kicks in all genres." [Trans.]

probably be true. In 1939, I had quite a few in my attic. I looked up Roché, offered him one, and he gave me quite a bit of money for it. And then it didn't cost much to live, you know. I didn't really have my own house. In Paris, I was living in the rue Larrey. In New York, it cost me forty dollars a month. That was minimum. Living is more a question of what one spends than what one makes. You have to know how much you can live on.

CABANNE: It's a matter of organization?

DUCHAMP: Yes. I lived very cheaply. It wasn't a problem. Obviously, I had some difficult moments, too.

CABANNE: In 1942, you returned to New York, and stayed there for four years. What was your life like in New York during the war?

DUCHAMP: It was very amusing because Peggy Guggenheim had also returned. Then all the Surrealists arrived, André Breton, André Masson, etc. There was lots of activity. Breton had gatherings. I attended. I never signed any petitions, things like that. He himself had to work; he spoke on the "Voice of America" during the whole war, with Georges Duthuit and all their friends. That was really a very nice thing to do.

CABANNE: Did you take part in their demonstrations?

DUCHAMP: There weren't any demonstrations. I went to see Breton. We got together. We did some little Surrealist games. There was activity, but the language bothered us a lot. We couldn't do anything big and what we could do in French was sort of useless.

CABANNE: You lived in New York during two successive wars. Was the New York of 1943 different from that of 1915?

DUCHAMP: Enormously different. From the point of view of social structure, it was completely different. Income taxes hardly existed in 1915 or 1916. After the crash of 1929, all that was changed by laws which completely transformed one's life. It was a much more brutal form of capitalism after the crash than before. The easy life was over after 1929 or 1930.

CABANNE: Did the European artists in New York keep working?

DUCHAMP: They kept working a lot.

CABANNE: You, on the contrary, didn't do much. Two or three covers for Breton's magazine, two or three window displays. And yet, if one judges from what is said by those who were there then, André Masson, for example, you had a considerable notoriety. You had an extraordinary moral position.

DUCHAMP: If you wish. It was based especially on the fact that I had lived in New York for a long time and, consequently, knew a lot of people.

It all comes down to a small group, really, a small portion of the population.

CABANNE: I don't think so.

DUCHAMP: But, yes. Since I didn't have exhibitions, there was no widespread interest. The interest was focused on the Americans who wanted to meet Breton, who had an enormous influence over there. It was right then that it began, because, before the war, there was an official organization called the WPA—or something like that—which would give every artist thirty or forty dollars a month,[12] on the condition that he give his paintings to the State. This was so he could live. It was a complete fiasco. The State's storerooms became filled with all these artists' rubbish. Beginning with the war, thanks to the presence of European artists, all that changed; it took the form of a movement in painting called Abstract Expressionism, which lasted for twenty years. It's barely over now, with some large-scale stars, like Robert Motherwell or Willem de Kooning, who make their money easily.[13]

CABANNE: So the American avant-garde was born during the Second World War?

DUCHAMP: They admit it. Everyone accepts the fact of Breton's influence. Of course, they always say that they did some extraordinary things themselves, but all the while accepting the origin, which was André Breton, André Masson, Max Ernst, Salvador Dali, with whom they mixed a lot. Matta, too.

CABANNE: Why did you accept the job of doing the notes for the catalogue of the Société Anonyme collection at Yale University? It wasn't your kind of job, and the notes are surprisingly banal.

DUCHAMP: Katherine Dreier wanted to do a completely traditional work, one that would shock no one, on her collection, which was full of interesting pieces. She came to me and I couldn't refuse. I attached much more importance to it than it had. At that moment I changed my profession; I became a historian. I didn't do so well, but I tried not to be too stupid, which unfortunately I was sometimes. I made some puns. For Picasso, I said that the public of any period needs a star, whether it be Einstein in physics, or Picasso in painting. It's a characteristic of the public, of the observer.

CABANNE: On this occasion, Lebel says that "the abyss of the censor's role became obvious to you."

DUCHAMP: Yes, but what's a censor?

[12] More like a hundred dollars. [Ed.]

[13] ? [Ed.]

CABANNE: In effect, when one writes a critical note on an artist, one takes sides. You seem to have refused to do that.

DUCHAMP: Yes. I didn't take sides. It was always either biographical or descriptive. It was a collection; there was no call to evaluate it, and my judgment wasn't important. I didn't want to write a book, either. It was simply a matter of putting down the things I knew.

CABANNE: You also scandalized New York with your portrait of George Washington with the American flag.

DUCHAMP: Yes, and I don't know why. Here's what happened. Alex Liberman, who is an artist and the editor of *Vogue* magazine—he still edits it, I believe—asked me if I wanted to do a cover for the fourth of July, which is the American equivalent of the French July fourteenth.[14] I accepted. I made a George Washington in the geographical shape of the United States. In place of his face, I put the American flag. It seems that my red stripes looked like dripping blood, and *Vogue* lost their minds. They thought it would cause a scandal. So they refused my project. They sent me forty dollars for my trouble and it never appeared. André Breton bought it for three hundred dollars.

CABANNE: In 1945, *View* magazine devoted a special issue to you.

DUCHAMP: Yes, it was very nice of them. They were doing issues on everyone. It was a monthly. They did a number on Max Ernst, one on André Masson, and while they still had the money, because each issue was very expensive and they made nothing from it, they also did an issue on me, for which I did the cover, a smoking bottle bearing, in the form of a label, a page from my military papers.

CABANNE: In 1945, you returned to Paris where, naturally, you passed unnoticed.

DUCHAMP: Oh! Completely!

CABANNE: You returned incognito.

DUCHAMP: I was a deserter, after all, even if I was sixty years old!

CABANNE: Had you become an American in the meantime?

DUCHAMP: No, not yet. Officially, that happened ten years later. I left France during the war, in 1942, when I would have had to have been part of the Resistance. I don't have what is called a strong patriotic sense; I'd rather not even talk about it.

CABANNE: Wasn't it surprising that, in 1946, you were so little known in Paris?

DUCHAMP: No, I hadn't had any exhibitions, or even group shows.

CABANNE: Still, you occupied a major position in contemporary art!

I Like Breathing Better than Working

[14] According to Liberman, it was for an "Americana" issue. [Ed.]

DUCHAMP: Forty years afterward! It's what I already told you. There are people who are born unlucky, and who simply never "make it." They're not talked about. This was a little the case with me. And then there are the dealers. They stand up for their stuff. But I had nothing to sell. They weren't going to get much of a kick out of beating my drum—I never helped those poor dealers make any money! I generally sold directly to Arensberg, when I sold.

CABANNE: But didn't this secrecy delight you?

DUCHAMP: I never have had any reason to complain. You're putting words in my mouth.

CABANNE: You never regretted it?

DUCHAMP: What?

CABANNE: Not being known.

DUCHAMP: No, not at all. Absolutely no regret.

CABANNE: Compared with Jacques Villon, who at that time was considered a very great painter?

DUCHAMP: I was delighted that Villon held that position for our family.

CABANNE: You weren't jealous?

DUCHAMP: Oh, no! Not in the least. To begin with, there were twelve years separating us. Jealousy generally exists between people of similar ages. Twelve years goes a long way toward avoiding jealousy.

CABANNE: In 1947, nine years after the first Surrealist exhibition, you were again one of the organizers of the one at the Maeght gallery in Paris.

DUCHAMP: Yes. I had asked that they make some rain. It poured down on banks of artificial grass, and on a billiard table. I also thought up the Hall of Superstitions. They went through with everything. But I wasn't there.

CABANNE: Faithful to your custom, you left for New York the night before the opening.

DUCHAMP: No, not the night before, I left a long time before. André Breton had asked Frederick Kiesler to come from New York, to oversee the work. As an architect, he was far more qualified than I to organize a Surrealist exhibition. There was another exhibition in New York, in 1942, when I arrived.

CABANNE: With the labyrinths?

DUCHAMP: With the strings. Imagine that these strings were really gun-cotton—they always are when they're attached to a light bulb, and I don't know how, but at a given moment they burned. Since guncotton burns without a flame, it was terrifying. But it worked out all right. It was rather funny.

CABANNE: At the Maeght gallery you did the cover for a catalogue: a

three-dimensional rubber breast. Did it have some special significance for you?

DUCHAMP: No, it was just another idea. I had seen these sponge-rubber "falsies" they sell in stores. I had to finish them, because, since they were made to be hidden, the manufacturers hadn't bothered with the details. So I worked on making little breasts, with pink tips.

CABANNE: In 1950, after the death of the Arensbergs, their collection went to the Philadelphia Museum. You're the only artist whose entire work, nearly, is in one museum, and that's rather extraordinary.

DUCHAMP: That's true, but it's because all these works were already in the same collection. So it was an automatic thing, not arranged with any previous intention. When poor Arensberg wanted to donate his collection somewhere, to avoid its being auctioned off, the Chicago Art Institute offered, I think, to display it on its walls for ten years; after this period, no guarantee: the attic or the basement.

Oh, yes! Museums are like that. The Metropolitan Museum in New York offered five years. Arensberg refused again. He also refused ten years. Finally, the Philadelphia Museum offered him twenty-five years. He accepted. It's already been up for twelve or thirteen years, so in twelve or thirteen more it might all go down into the storeroom or the basement!

CABANNE: In 1953, Picabia was dying and you sent him a rather disturbing telegram.

DUCHAMP: It's hard to write to a dying friend. One doesn't know what to say. You have to get around the difficulty with a sort of joke. Good-by, right?

CABANNE: You cabled, "Dear Francis, see you soon."

DUCHAMP: Yes, "see you soon." That's even better. I did the same thing for Edgard Varèse, when he died a few months ago. Barzun's son Jacques had started organizing a sort of ceremony at Columbia University. He had asked that we send messages, which he would read aloud himself. So I simply sent, "See you soon!" It's the only way of getting out of it. If you make a panegyric, it's ridiculous. Everyone isn't a Bossuet.

CABANNE: At that time, you made some readymades again, which you hadn't done for ten years.

DUCHAMP: They weren't readymades, but sculpted things, plaster things....

CABANNE: How long had it been since you had worked?

DUCHAMP: Since 1923. I don't count the things in 1934, the optical experiments; but they were still work, a lot of work.

CABANNE: The "Green Box" is something too.

DUCHAMP: And the "Box in Valise."

CABANNE: There's a sort of eroticism in these sculptures. . . .

DUCHAMP: Clearly. They weren't completely *trompe-l'œil*, but still, they're very erotic just the same. I only did two or three things like that.

CABANNE: The "*Objet-dard*," a phallic readymade, and the "Female Fig Leaf."

DUCHAMP: Yes. And "Chastity Wedge," which I offered to my wife Teeny; it was my wedding present to her. We still have it on our table. We usually take it with us, like a wedding ring, no?

CABANNE: Yes, I understand.

DUCHAMP: It amused me.

CABANNE: Like the "Female Fig Leaf," a cast taken of the female sexual organs. What is the place of eroticism in your work?

DUCHAMP: Enormous. Visible or conspicuous, or, at any rate, underlying.

CABANNE: In "The Bride," for example?

DUCHAMP: It's there, too, but it was a closed-in eroticism, if you like, an eroticism which wasn't overt. It wasn't implied, either. It's a sort of erotic climate. Everything can be based on an erotic climate without too much trouble.

I believe in eroticism a lot, because it's truly a rather widespread thing throughout the world, a thing that everyone understands. It replaces, if you wish, what other literary schools called Symbolism, Romanticism. It could be another "ism," so to speak. You're going to tell me that there can be eroticism in Romanticism, also. But if eroticism is used as a principal basis, a principal end, then it takes the form of an "ism," in the sense of a school.

CABANNE: What personal definition of eroticism would you give?

DUCHAMP: I don't give it a personal definition, but basically it's really a way to try to bring out in the daylight things that are constantly hidden—and that aren't necessarily erotic—because of the Catholic religion, because of social rules. To be able to reveal them, and to place them at everyone's disposal—I think this is important because it's the basis of everything, and no one talks about it. Eroticism was a theme, even an "ism," which was the basis of everything I was doing at the time of the "Large Glass." It kept me from being obligated to return to already existing theories, aesthetic or otherwise.

CABANNE: Still, in your work, this eroticism has remained disguised for a rather long time.

DUCHAMP: Always disguised, more or less, but not disguised out of shame.

CABANNE: No, hidden.

DUCHAMP: That's it.

CABANNE: Let's say underlying.

DUCHAMP: Underlying, yes.

CABANNE: In Houston, Texas, in 1957, you took part in a discussion on art at the University, with some very serious people.

DUCHAMP: Yes. I got in my two cents' worth, on the artist as a medium. I read a paper, and there was a discussion.

CABANNE: At the end of this discussion you said, "I've played my part as artistic clown." You have a funny opinion of yourself!

DUCHAMP: Naturally, because all these things I was doing were demanded, or requested. I had no reason to say, "But I'm above all that, I don't want to do it." It was amusing. In general, speaking in public is a part of an artist's life. But it's very hard to speak in public, unless you're a born orator. It was a game for me to see what I could do, to keep from being ridiculous. When you hear your own voice in front of five hundred people, it's very unpleasant, unless you're used to it and like it, like a politician. As far as I was concerned, it broadened my horizon a little. Later, I gave talks on myself, my work. It was always the same subject.

CABANNE: Did you take yourself seriously?

DUCHAMP: I wasn't taking myself seriously; I was making some money. That was the main reason. To make things easy and not be obliged to go into complicated theories, I always spoke on my own work. When I used a slide projector, I explained each picture, more or less. It was a very simple system, and it's done often in the United States, where artists are often invited to speak. To students, generally.

CABANNE: One has the impression that every time you commit yourself to a position, you attenuate it by irony or sarcasm.

DUCHAMP: I always do. Because I don't believe in positions.

CABANNE: But what do you believe in?

DUCHAMP: Nothing, of course! The word "belief" is another error. It's like the word "judgment," they're both horrible ideas, on which the world is based. I hope it won't be like that on the moon!

CABANNE: Nevertheless, you believe in yourself?

DUCHAMP: No.

CABANNE: Not even that.

DUCHAMP: I don't believe in the word "being." The idea of being is a human invention.

CABANNE: You like words so much?

DUCHAMP: Oh, yes, poetic words.

CABANNE: "Being" is very poetic.

DUCHAMP: No, not at all. It's an essential concept, which doesn't exist at

all in reality, and which I don't believe in, though people in general have a cast-iron belief in it. No one ever thinks of not believing in "I am," no?

CABANNE: What is the most poetic word?

DUCHAMP: I have no idea. I don't have one handy. In any case, they would be words distorted by their sense.

CABANNE: Word games?

DUCHAMP: Yes, word games. Assonances, things like that, like the "delay" in the "Glass;" I like that very much. "Backward," that means something.

CABANNE: Even the word "Duchamp" is very poetic.

DUCHAMP: Yes. Nevertheless, Jacques Villon didn't waste any time changing names, not only "Duchamp" into "Villon," but also "Gaston" into "Jacques!" There are periods when words lose their salt.

CABANNE: You're the only brother to keep his name.

DUCHAMP: I was sort of obligated to. One of us had to!

I Live the Life of a Waiter

PIERRE CABANNE: You've just returned from London where, at the Tate Gallery (1966), an important retrospective of your work took place. I thought that exhibitions were "histrionic demonstrations" which you didn't approve of?

MARCEL DUCHAMP: But they always are! You're on stage, you show off your goods; right then you become an actor. It's only one step from the painter hidden in his studio, painting, to the exhibition. You have to be present at the opening; you're congratulated, it's so hammy!

CABANNE: You're very graceful now about accepting this hamminess, which you avoided all your life.

DUCHAMP: One changes. One accepts everything, while laughing just the same. You don't have to give in too much. You accept to please other people, more than yourself. It's sort of politeness, until the day when it becomes a very important tribute. If it's sincere, that is.

CABANNE: Was that the case?

DUCHAMP: It's the case momentarily, but these things aren't always followed up. There are six thousand exhibitions in the world every day, so if every artist who exhibited thought that it was the end of the world for him or, on the contrary, the height of his career, it would be a bit ridiculous. You have to see yourself as one of six thousand painters. Come what may!

CABANNE: How many one-man shows have you had?

DUCHAMP: Three. The one in Chicago, which I don't even remember...

CABANNE: At the Arts Club.

DUCHAMP: The one in Pasadena two years ago, in California, which was a large show, including things lent by the Philadelphia Museum. It was quite complete. Then another one-man show at the Cordier-Ekstrom Gallery in New York, last year, but not so complete.

CABANNE: There was also the readymade show at the Schwarz gallery in Milan.

DUCHAMP: Yes, that's true. Schwarz has had one or two of them, because he's passionate about them. I've exhibited often with my brothers. I was in a show with Villon and Duchamp-Villon at the Guggenheim Museum in New York. But I haven't had many of what are known as one-man shows.

I think of all these young people who are trying to have their one-man show at twenty. They imagine that's what it takes to be a great painter!

CABANNE: Outside of the Arensberg collection in the Philadelphia Museum, where are your works?

DUCHAMP: An important group belongs to Mary Sisler, who bought about fifty things, things rediscovered in Paris at the homes of friends to whom I had given them in the old days. Especially very old things, 1902, 1905, 1910—she made a nice collection out of them. She showed them last year at the Ekstrom Gallery in London. It was really an absolutely remarkable and complete exhibition; I couldn't have asked for anything better. Henri-Pierre Roché also had a lot of my things, old things I had given him. There are also some in my family, with my sister Suzanne, and in the Museum of Modern Art in New York, to which Katherine Dreier had left part of her collection. Some collectors too; Mr. Bomsel, André Breton, Maria Martins in Brazil. Peggy Guggenheim has the "Sad Young Man" in Venice. I forgot Yale University, where the Société Anonyme collection is kept. My wife, Teeny, also has a few things at our place in New York.

CABANNE: I think "The Chess Players," at the Museum of Modern Art in Paris, is the only painting by you in a European museum.

DUCHAMP: Yes, I think so, too. I haven't seen any others. There aren't any, it's true.

CABANNE: What impression did the retrospective at the Tate Gallery make on you?

DUCHAMP: An excellent one. When your memory's warmed up, you see better. You go through it chronologically; the man's really dead, with his life behind him. It's a little like that, except I'm not dying! Each thing brought up a memory. And I wasn't at all embarrassed by the things I didn't like, that I was ashamed of, that I would have wanted to

keep out. No, not at all. It was simply being laid bare, kindly, with no bruises, no regrets. It's quite agreeable.

CABANNE: You're the first in art history to have rejected the idea of painting, and therefore to have walked out of what's known as the imaginary museum. . . .

DUCHAMP: Yes. Not only easel painting, but any kind of painting.

CABANNE: Space in two dimensions, if you like.

DUCHAMP: I find that it's a very good solution for a period like ours, when one cannot continue to do oil painting, which, after four or five hundred years of existence, has no reason to go on eternally. Consequently, if you can find other methods for self-expression, you have to profit from them. It's what happens in all the arts. In music, the new electronic instruments are a sign of the public's changing attitude toward art. The painting is no longer a decoration to be hung in the dining room or living room. We have thought of other things to use as decoration. Art is taking more the form of a sign, if you wish; it's no longer reduced to a decorative role. This is the feeling that has directed me all my life.

CABANNE: Do you think easel painting is dead?

DUCHAMP: It's dead for the moment, and for a good fifty or a hundred years. Unless it comes back; one doesn't know why, but there's no reason for it. Artists are offered new media, new colors, new forms of lighting; the modern world moves in and takes over, even in painting. It forces things to change naturally, normally.

CABANNE: For you, who are the greatest contemporary painters?

DUCHAMP: Oh! Contemporaries . . . I don't know. When does "contemporary" start? In 1900?

CABANNE: This half century, if you like.

DUCHAMP: Among the Impressionists, Seurat interests me more than Cézanne. Afterward, Matisse interests me enormously. Very few of the Fauves do. Braque was primarily a Cubist, although he was an important Fauve. Then comes Picasso, like a very powerful lighthouse; he fills the role the public demands, that of the star. It's fine, as long as it lasts. Manet was that way, at the turn of the century. When you talked about painting, you always talked about Manet; painting didn't exist without Manet.

As for our period, I don't know. It's hard to judge. I like the young Pop artists a lot. I like them because they got rid of some of the retinal idea, which we have talked about. With them I find something really new, something different, while painter after painter, since the beginning of the century, has tended toward abstraction. First, the Impressionists simplified the landscape in terms of color, then the Fauves simplified

it again by adding distortion, which, for some reason, is a characteristic of our century. Why are all the artists so dead-set on distorting? It seems to be a reaction against photography, but I'm not sure. Since photography gives us something very accurate from a drawing point of view, it follows that an artist who wants to do something else would say, "It's very simple, I'll distort things as much as I can, and by doing that I'll be as free of photographic representation as possible." It's very clear with all painters, whether they're Fauves, Cubists, and even Dadaists or Surrealists.

With the latest Pop artists, there is less of that idea of distortion. They borrow from things already made, ready-made drawings, posters, etc. So it's a very different attitude that makes them interesting in my eyes. I don't want to say that they're geniuses, because that's hardly important. Things take place in slices of twenty or twenty-five years, or less. Where will they put it all? In the Louvre? I have no idea. Furthermore, it doesn't matter at all. Look at the pre-Raphaelites; they lit a small flame, which is still burning despite everything. They aren't very well liked, but they'll come back—they'll be rehabilitated.

CABANNE: You think so?

DUCHAMP: Oh, surely! Remember Art Nouveau, the "Modern" style, the Eiffel Tower, and all the rest!

CABANNE: Every twenty or thirty years what was rejected forty years before is rehabilitated.

DUCHAMP: It's almost automatic, especially in the last two centuries, because during them we've seen one "ism" follow after another. Romanticism lasted forty years, then Realism, Impressionism, Divisionism, Fauvism, etc.

CABANNE: From a series of conversations you had with James Johnson Sweeney on American television, I noted this sentence: "When an unknown artist brings me something new, I all but burst with gratitude." What do you think the "new" is?

DUCHAMP: I haven't seen so much of it. If someone brings me something extremely new, I'd be the first to want to understand it. But my past makes it hard for me to look at something, or to be tempted to look at something; one stores up in oneself such a language of tastes, good or bad, that when one looks at something, if that something isn't an echo of yourself, then you do not even look at it. But I try anyway. I've always tried to leave my old baggage behind, at least when I look at a so-called new thing.

CABANNE: What new things have you seen in your life?

DUCHAMP: Not much. The Pop artists are new enough. The Op artists are

new too, but don't seem to me to have an enormous future. I'm afraid that when you do it twenty times, it falls very fast, it's too monotonous, it's too repetitive; whereas the Pop artists, especially the French, men like Arman, like Tinguely, have done very personal things that no one would have dreamed of thirty years ago. I don't attach very much importance to what I think is better; it's simply an opinion. I don't intend to offer a definitive judgment about all these things.

CABANNE: And Martial Raysse?

DUCHAMP: I like him very much. He is very difficult to understand, because what he does is rather shocking; due to his introduction of the disagreeable neon light. I understand what he wants. I know him, I met him, and I like him as an individual; he has a very quick intelligence. He'll recharge himself. At least, he should change as he goes along, even if his basic idea stays the same; he'll find other means of expressing it.

CABANNE: All these young painters are a little like your children.

DUCHAMP: People say that. . . . I suppose every young generation needs a prototype. In this case, I play that role. I'm delighted to. But it doesn't mean any more than that. There's no glaring resemblance between what I've done and what they're doing now. Furthermore, I did as few things as possible, which isn't like the current attitude of making as many as you can, in order to make as much money as possible.

Looking at what the young people are doing now, some people thought that I had had ideas somewhat similar to theirs and, consequently, we felt good about each other. But that's all. I don't see many artists, even in New York. I first met Raysse here, in Paris, and then in New York again. Spoerri, Arman, and Tinguely are very intelligent.

CABANNE: Arman is very cultured.

DUCHAMP: Yes, very cultured, extraordinary. Well, I respect that. Since I wasn't very cultured, in the true sense of the word, I am always astonished by people who can talk about things I know nothing about, and do it well. This isn't the case with artists in general, who are limited.

CABANNE: Do you know the young man whose friends call him "Duchamp the Second," and whose name is Ben, Benjamin Vautier? He lives in Nice.

DUCHAMP: No, I have never seen him.

CABANNE: Have you heard of him?

DUCHAMP: No. You know, I only stay one night when I go to Nice. Still, it seems to me that I received some papers with rather extraordinary things. . . .

CABANNE: Ben is a fellow about thirty-five years old who, having decided

that an art work lives above all in its intention, is trying to make his life a work of art. Instead of having exhibitions, he exhibits himself. He was in a gallery window in London for two weeks.

DUCHAMP: Yes, yes. I think that's it. I received some things in letters . . . but I don't know him personally. Is he a friend of Arman?

CABANNE: Yes, he's from Nice, like Raysse and Arman. They're part of what's called the School of Nice. It's odd that he never tried to get in touch with you.

DUCHAMP: If he's staying in Nice, I should go see him.

CABANNE: Considering your importance to him, he could come to see you. . . .

DUCHAMP: Not necessarily. It depends on the state of his finances!

CABANNE: He sells phonograph records. Apparently his behavior causes huge scandals in Nice.

DUCHAMP: I'll try to see him. The importance that the School of Nice has taken on is funny.

CABANNE: What's the difference between the artistic climates in Paris and New York?

DUCHAMP: It's a madhouse in New York. Here in Paris, as far as I can see, it seems less so. Obviously, it isn't a matter of going to Saint-Germain-des-Prés or Montparnasse. It always takes so long to get started in Paris. Even if there are interesting people, they don't influence the rest. What's left is the majority of the crowd, with its education, its habits, its idols. The ones here always have these idols on their shoulders, you see? They have no sense of gaiety. They never say, "I'm young, I can do what I want, I can dance."

CABANNE: Americans don't have a past.

DUCHAMP: I agree, they don't have such a past. They go to enormous trouble to learn art history with which every Frenchman, or every European, is imbued, so to speak. I think that's the difference.

But everything can change very swiftly. In America, as in France. There's no "art world" any more, no capital, here or there. Still, the Americans persist in wanting to smash the Paris hegemony. They are idiots, because there is no hegemony, in Paris or in New York. If there is one, it will be in Tokyo, since Tokyo is even swifter. I often get letters from Japan; they want me to fly over there. I will not go. First, I have no desire to go to Japan, I have no desire to go to India, I have no desire to go to China. I've had enough with Europe and America.

CABANNE: Why did you become an American citizen?

DUCHAMP: Because I found over there a very agreeable atmosphere. I have many friends, too.

CABANNE: Couldn't you have lived in the United States without becoming an American citizen?

DUCHAMP: Yes and no. It's simpler. For traveling, it's extremely convenient to have an American passport; your bags are never opened! I take my cigars from country to country with no trouble; all I have to do is show my American passport.

CABANNE: You could go into smuggling!

DUCHAMP: Absolutely. There's a great future in it for me!

CABANNE: Why have you never had a one-man show in France?[1]

DUCHAMP: I don't know. I never understood. I think it's a question of money. Putting on a show is very expensive; there are not only the shipping costs. . . .

CABANNE: They do pretty expensive shows, all the same.

DUCHAMP: Yes, Van Gogh or Turner; that's going into art history, which is another question. But with the moderns . . .

CABANNE: There are plenty of Braque or Picasso shows.

DUCHAMP: Yes, but comparatively they don't cost as much.

CABANNE: But insurance is high.

DUCHAMP: I agree, the insurance is high, but at least the shipping isn't much. Obviously the shipping rates would go higher in my case, but it's not insurmountable. The English did it.

CABANNE: Does the Philadelphia Museum lend the Arensberg collection?

DUCHAMP: Yes, but not for more than three months in a row. Which is the case with London at the moment.

CABANNE: The Tate retrospective will last a month and a half; another month and a half could have been planned for Paris.

DUCHAMP: Yes, yes. But maybe the Museum of Modern Art in Paris isn't free. What's on there now?

CABANNE: A Pignon retrospective.

DUCHAMP: (. . .)

CABANNE: Do you know André Malraux?

DUCHAMP: No, I've never met him.

CABANNE: How is it that no curator of a French museum has come to you for a show?

DUCHAMP: Last year, Mathey said he wanted to meet me. I went to see him. He told me, "I'd really like to do something with you, but I'm tied down. I must have the agreement of the higher-ups." And nothing came of it. He was full of good will, but that's all. And Dorival came to

[1] He did have a show, at the Museum of Modern Art in Paris, a few months after his book was published (spring 1967). [Ed.]

see me about the Dada exhibition;[2] he never mentioned the possibility of doing something about me. But I'm not very bothered by that. I understand it very well. If they wanted to see a show of my works here, it would be done. It's the picture dealers who are behind it. The dealers have nothing to gain from me, you understand?

CABANNE: The dealers maybe. But the museums?

DUCHAMP: The museums are run, more or less, by the dealers. In New York, the Museum of Modern Art is completely in the hands of dealers. Obviously this is a manner of speaking, but it's like that. The museum advisers are dealers. A project has to attain a certain monetary value for them to decide to do something.

As far as I'm concerned, I have nothing to say, I don't hold much for having shows; I don't give a damn!

CABANNE: Happily for you!

DUCHAMP: I don't lose any sleep over it. I'm happy with things as they are.

CABANNE: During the three months you've just spent in Paris, what shows did you like particularly?

DUCHAMP: I didn't see any.

CABANNE: You didn't go to the Salon de Mai?

DUCHAMP: No, not even that. My wife went. I didn't want to. I don't want to see shows.

CABANNE: Aren't you curious?

DUCHAMP: No. Not about this kind of thing. Note, this is not taking sides, it's not desire or need—it's an indifference, in the simplest sense of the word.

CABANNE: You meant to go to the Salon de Mai, you told me.

DUCHAMP: Yes. I thought about it. There was no reason for not going. I don't know why I didn't go. Art, in the social sense of the word, doesn't interest me, even with people like Arman, whom I like a lot. My pleasure is in chatting with people like him, rather than going to see what they do.

CABANNE: So the artist's attitude counts more for you than his art?

DUCHAMP: Yes. The individual, man as a man, man as a brain, if you like, interests me more than what he makes, because I've noticed that most artists only repeat themselves. This is necessary, however, you can't always be inventive. Only, they have that old habit which inclines them to do one painting a month, for example. Everything depends on their working speed. They believe they owe society the monthly or yearly painting.

² Bernard Dorival put on the Duchamp exhibition in Paris mentioned in the previous note. [Ed.]

CABANNE: Do you know that young painters like Arman or Raysse are making fortunes?

DUCHAMP: I know. . . . Amassing alarm clocks. It's very good, however.

CABANNE: You aren't shocked?

DUCHAMP: Oh, no! For them, I'm a little shocked, but not for myself. Only, if they continue to amass the same things, it will become impossible to look at them in twenty years. Arman is very capable of changing, however.

CABANNE: I think he's the most intelligent of all.

DUCHAMP: I think so, yes. I like Tinguely very much, too; but he's more of a mechanic.

CABANNE: You aren't shocked that artists have a right to Social Security?

DUCHAMP: You know, as far as I'm concerned, being an American and being over seventy years old, I get a very substantial sum from the government, and that's without having paid in very much; fifty-seven dollars a month is still something! Naturally, it's not as an artist that I have a right to this sum, it's a simple matter of age. At sixty-five, to draw that allowance, you don't have to be earning, and if you are earning, you deduct it from what you're given; but after seventy, you can make a million a month, and you'll still draw your fifty-seven dollars.

CABANNE: What do you think of happenings?

DUCHAMP: I like happenings very much because they are something diametrically opposed to easel painting.

CABANNE: They adhere completely to your theory of the "onlooker."

DUCHAMP: Exactly. Happenings have introduced into art an element no one had put there: boredom. To do a thing in order to bore people is something I never imagined! And that's too bad, because it's a beautiful idea. Fundamentally, it's the same idea as John Cage's silence in music; no one had thought of that.

CABANNE: And Yves Klein's emptiness.

DUCHAMP: Yes. The introduction of new ideas is valuable only in happenings. You can't do a boring painting. Obviously it's been done, but it's easier in the semitheatrical realm. There is also a speed which is amazing; the real happening lasts only twenty minutes at the maximum, because the people remain standing. In certain cases, you're not even given anything to sit on. But that's begun to change.

CABANNE: Yes, it's taking on considerable proportions.

DUCHAMP: Two or three hours. At the beginning, the people remained standing and then, when it was time to leave, a gasoline lawnmower came along, and forced everyone to get the hell out! It was exaggerated,

but remarkable, because it was truly new, and it infuriated the public.

CABANNE: The happenings I've seen—and I've seen them in France only—seemed very erotic to me.

DUCHAMP: Yes.

CABANNE: Was it so at the beginning?

DUCHAMP: No, not so much. Whereas with Jean-Jacques Lebel, for example, there's a very clear need for eroticism.

CABANNE: Recently, they showed the striptease of a pederast disguised as a nun. . . .

DUCHAMP: Yes. But I don't know if you saw the one two or three years ago on the Boulevard Raspail, in which plucked hens were thrown around. It was ghastly! Another time people were rolling in cream or in mud. It's completely maddening. . . .

CABANNE: How do you see the evolution of art?

DUCHAMP: I don't see it, because I doubt its value deep down. Man invented art. It wouldn't exist without him. All of man's creations aren't valuable. Art has no biological source. It's addressed to a taste.

CABANNE: It isn't a necessity, in your eyes?

DUCHAMP: People who talk about art have turned it into something functional by saying, "Man needs art, in order to refresh himself."

CABANNE: But there isn't any society without art?

DUCHAMP: There isn't any society without art because those who look at it say so. I'm sure that the people who made wooden spoons in the Congo, which we admire so much in the Musée de l'Homme, do not make them so they can be admired by the Congolese.

CABANNE: No, but at the same time they make fetishes, masks. . . .

DUCHAMP: Yes, but these fetishes were essentially religious. It is we who have given the name "art" to religious things; the word itself doesn't exist among primitives. We have created it in thinking about ourselves, about our own satisfaction. We created it for our sole and unique use; it's a little like masturbation. I don't believe in the essential aspect of art. One could create a society that rejects art; the Russians weren't far from doing it. It isn't funny, but it's a thing to be considered. But what the Russians tried to bring about is no longer possible, with fifty nations. There is too much contact, too many points of communication from one country to another.

CABANNE: Who are your friends?

DUCHAMP: Many people. I don't have any enemies, or very few. There are people who don't like me, that's for sure, but I don't even know them. I mean that it's not a declared hostility, it's not a war. In general, I only have friends.

CABANNE: Who have your best friends been?

DUCHAMP: Obviously, Francis Picabia, who was a teammate, so to speak. Pierre de Massot is nice, and André Breton very nice, too; only he can't be approached. He's playing the great man too much, completely clouded by the idea of posterity.

CABANNE: Have you seen him recently?

DUCHAMP: No, I haven't been to see him. It's come to the point where I don't dare telephone him any more, it's ridiculous.

CABANNE: He must know you're here.

DUCHAMP: He doesn't even bother. That's what annoys me, because I'm ten years older than he is. I think I have the right to expect to hear from him, a telephone call, something.

CABANNE: Even the Pope gets around now!

DUCHAMP: Certainly! He went to Jerusalem. Well, I don't understand. Anyway, I don't have anything special to tell Breton. So it would be a visit out of politeness and friendship. I'd love to see him, but it has to happen easily; if he made an effort, I'd reply immediately. That's all. That's all there is to it. It's a somewhat difficult sort of friendship, you see what I mean? We don't play chess together, you understand?[3]

CABANNE: Who have you seen during your stay in Paris this time?

DUCHAMP: Not many people. A mass of people asking me for articles. Mostly professionals.

CABANNE: Nuisances like me!

DUCHAMP: Like you, right! No, I mean nothing new has happened. I don't go out very much. I don't like going out so much. Obviously, I have relatives. My wife has a married daughter in Paris, whom we see often, but I haven't seen the people you usually see when you travel. One sees so-and-so, one sees Malraux, etc. I never do any of that. There is no one I see in a more or less official capacity, or to discuss certain questions. I really have the life of a restaurant waiter.

CABANNE: What do you do all day?

DUCHAMP: Nothing. I'm on the go a lot, because one always has a lot of engagements. We went to Italy, to Baruchello's, the painter, whom I like very much. He does big white paintings, with little tiny things you have to look at very close up.

After Italy, we went to England. Truly, I haven't done anything important since I arrived. Besides, when I come here, it's with the idea of resting. Resting up for nothing, since one is always tired, even of existing.

[3] André Breton died in Paris some months after these remarks. [Ed.]

CABANNE: Do you lead a more active life in New York?

DUCHAMP: No. It's the same thing. Exactly the same. The difference is that there people telephone you less, don't try too hard to get hold of you. That's the danger in Paris. They want you to sign petitions, to get involved, *engagé*, as they say. You feel obliged to follow.

CABANNE: You're like Cézanne; you're afraid of being hooked.

DUCHAMP: That's it. It's the same idea. A lot of people feel that way. If it isn't a literary movement, it's a woman; it's the same thing.

CABANNE: Last year, at the Creuze gallery, there was a show in which three young painters, Arroyo, Aillaud, and Recalcati, did a series of collaborative paintings called "The Tragic End of Marcel Duchamp." In a manifesto they published, they sentenced you to death, accusing you of being bereft of "the spirit of adventure, the freedom of invention, the sense of anticipation, and the power of transcending. . . ." Did you see these canvases?

DUCHAMP: Of course. It was just before I left, in October. Creuze telephoned and asked me to come see them. He wanted to explain what was going on, and to ask me what to do, if I wanted them removed. I told him, "Don't worry about it, either you want the publicity, or you don't. I don't care. There's nothing to say about it; these people want some publicity, that's all." It was a flop.

CABANNE: There was a demonstration. Some of the Surrealists wanted to slash the paintings.

DUCHAMP: Yes, but I don't think they did it.

CABANNE: No, they didn't.

DUCHAMP: The Surrealists wanted to print a piece in *Combat* magazine. *Combat* didn't print it. They put out a sheet, which was a sort of answer to the manifesto. It was a semiflop. A few columnists wanted to mention it. I told them, "If you want to be nice to these young people, you have only to do so." I'm becoming an expert in this kind of thing; the only refutation is indifference. It seems that one of the three painters is a pseudo-philosopher, a writer.

CABANNE: Yes, Aillaud. He's an architect's son, a very intellectual boy.

DUCHAMP: He knows how to write, and what he wrote was very good, even if it meant nothing. But he accused me of things which made no sense.

CABANNE: Indeed, it is rather surprising to accuse you of lacking a spirit of adventure and of invention. . . .

DUCHAMP: José Pierre came to see me about protesting; I told him, "Don't do anything. If you want to advertise them, go ahead, but you won't be getting anything out of it yourself; and they will." It's the infancy of the art of publicity.

CABANNE: The last painting in the series depicted your burial. . . .

DUCHAMP: It was very pretty.

CABANNE: Your pallbearers were Robert Rauschenberg, Claes Oldenburg, Martial Raysse, Andy Warhol, Restany, and Arman.

DUCHAMP: Dressed as American Marines! I swear it was amusing to look at. It was awful as painting, but that doesn't matter; it had to be that way for them to want to prove something; it was horribly painted, but it was very clear. It was a hell of a job.

CABANNE: What do you think of young people nowadays?

DUCHAMP: They're fine, because they're active. Even if it's against me; that doesn't matter. They think enormously. But nothing comes of it which isn't old, out of the past.

CABANNE: From tradition.

DUCHAMP: Yes. That's what's irritating; they can't get away from it. I'm sure that when people like Seurat started to do something, they really just wiped the past right out. Even the Fauves, even the Cubists did it. It seems that today, more than at any other time in this century, there are strong ties with the past. It lacks audacity, originality. . . .

CABANNE: What do you think of the beatniks?

DUCHAMP: I like them very much; it's a new form of young people's activity; it's fine.

CABANNE: Are you interested in politics?

DUCHAMP: No, not at all. Let's not talk about it. I don't know anything about it, I don't understand anything about politics, and I say it's really a stupid activity, which leads to nothing. Whether it leads to communism, to monarchy, to a democratic republic, it's exactly the same thing, as far as I'm concerned. You're going to tell me that men need politics in order to live in society, but that in no way justifies the idea of politics as a great art in itself. Nevertheless, this is what politicians believe; they imagine themselves doing something extraordinary! It's a little like notaries, like my father. The politician's style is something like the notary's. I remember my father's legal papers; the language was killingly funny; the lawyers in the United States use the same language. I don't go for politics.

CABANNE: Did you know John F. Kennedy?

DUCHAMP: No, not personally. He didn't see a lot of artists. His wife did. He was very nice, a remarkable man, but that goes a little beyond the idea of politics. When a remarkable person has something to do, whether it's for his country or not, he can do anything, and it will be extraordinary. Kennedy had chosen politics.

CABANNE: What do you think of Charles de Gaulle?

DUCHAMP: I don't think about him any more. When you've been born and lived the same period. . . . He's about my age, isn't he?

CABANNE: He's three years younger.

DUCHAMP: There were times when he was a hero, but heroes who live too long are doomed to a downfall. That happened to Pétain. Didn't Clemenceau die rather young?

CABANNE: Not at all, he was very old when he died!

DUCHAMP: But he had retired, and was in a coma. In any case, he kept his aura.

CABANNE: Yes, because he had retired . . . or rather had been retired!

DUCHAMP: Well, I have no opinion. People complain a lot about de Gaulle. I listen to what they say, but I don't know what they're talking about. People have special ideas about money, income, etc. That never interested me. I don't understand.

CABANNE: Who is your favorite historical character?

DUCHAMP: Historical? I don't know. Not many, because they're not the people who interest me very much, whether they're named Napoleon, Caesar, or you-name-him! Generally, there's some gross exaggeration. The idea of the great star comes directly from a sort of inflation of small anecdotes. It was the same in the past. It's not enough that two centuries later we have to look at certain people as if they were in a museum; the entire thing is based on a made-up history.

CABANNE: Do you go to the movies often?

DUCHAMP: Quite often.

CABANNE: Even in Paris?

DUCHAMP: Yes. I went to see Godard's *Masculin-Féminin*. It's the only one I've seen. I'd gladly go more often, but we don't have time. You don't do anything, and you don't have time! You have to plan to go to the movies. Especially in Neuilly, it's so far out. . . .

CABANNE: Do you go more often in New York?

DUCHAMP: When I can. I only see happy films when possible, not those big, stupid pseudo-historical films. I love good, amusing movies.

CABANNE: They are primarily a diversion for you.

DUCHAMP: Oh, yes! Completely. I don't believe in cinema as a means of expression. It could be one, later perhaps; but, like photography, it doesn't go much further than a mechanical way of making something. It can't compete with art. If art continues to exist. . . .

CABANNE: What was the last play you liked?

DUCHAMP: I saw *The Screens*. I don't know Jean Genet's work very well. I had seen *The Balcony* in English. I liked *The Screens* very much. It's amazing.

CABANNE: Do you read a lot?

DUCHAMP: No. Not at all. There are things I never read, which I never will read. Like Proust; in the end I never read him. When I was twenty, Proust was thought to be more important than Rimbaud and others. Obviously, times have changed and different things are current; still, one doesn't feel obliged to read him.

CABANNE: And among the contemporary novelists?

DUCHAMP: I don't know their work. Robbe-Grillet, Michel Butor, I don't know their work. I don't know anything about the current novelists, the new novelists, *la nouvelle vague*. I once tried vaguely to read one, but I wasn't interested enough to arrive at any judgment.

CABANNE: What interests you in literature?

DUCHAMP: Always the same things that I've liked. Mallarmé very much, because in a sense he's simpler than Rimbaud. He's probably a bit too simple for those who understand him well. His Impressionism is contemporary with Seurat's. Since I still don't completely understand him, I find him very pleasurable to read for sound, as poetry that you hear. It isn't simply the structure of his poems or the depth of his thought that attract me. Even Rimbaud must be fundamentally an Impressionist . . .

CABANNE: You're leaving for two months in Cadaqués, Spain. What are you going to do there?

DUCHAMP: Nothing. I have a very pretty, very nice terrace. I made an awning. I made it out of wood, because there's wind down there. I made one three years ago; I don't know if it's lasted this winter; I'll send you post cards and let you know!

CABANNE: Is this awning your last readymade?

DUCHAMP: It's not ready-made, it's handmade!

CABANNE: Is your life at Cadaqués different from your life in Paris or New York?

DUCHAMP: I stay in the shade. It's marvelous. Everyone else, however, heads for the sun to get tan; I hate it.

CABANNE: At the beginning of our conversation, you said that the word "art" probably came from Sanskrit and meant "to make." Aside from this awning, haven't you ever felt like using your hands, to "make" something?

DUCHAMP: Oh, yes. Yes. I'm very handy. I often repair objects. I'm not at all afraid, like people who don't know how to fix an electrical outlet. I learned the rudiments of these things; unfortunately I don't know everything about it, nor am I very exact or very precise. When I see certain friends of mine doing the same things, I really admire them.

But I get along all right. It's fun to do things by hand. I'm on guard, because there's the great danger of the "hand," which comes back, but since I'm not doing works of art, it's fine.

CABANNE: You never want to pick up a brush or a pencil?

DUCHAMP: No, especially not a brush. But I could. If I had an idea pop into my head, like the "Glass," I'd do it for sure.

CABANNE: If someone offered you a hundred thousand dollars to do a painting?

DUCHAMP: Oh, no! Nothing doing! During a talk in London, I answered questions for two hours. I was asked, "If you were offered a hundred thousand dollars, would you accept?"

I told them the story about New York, in 1916, when Knoedler, after seeing the "Nude Descending a Staircase," had offered me ten thousand dollars a year, for my entire production, naturally. I said no, and I wasn't rich, either. I could have very well accepted ten thousand dollars, but no, I sensed the danger right away. I had been able to avoid it until then. In 1915–16, I was twenty-nine, so I was old enough to protect myself.

I'm telling you this simply to explain my attitude. It would be the same today, if I were offered a hundred thousand dollars to do something.

I had small orders, like the sugar cage which Katherine Dreier's sister asked for. She absolutely had to have something by me. I told her I'd be glad to, but on the condition that I could do whatever I wanted. I made that cage. She hated it. She sold it to her sister, and her sister hated it too, so she sold it to Arensberg, still for the same price, three hundred dollars.

CABANNE: If someone made you the same request now, would you accept?

DUCHAMP: If it were a matter of friendship, and they let me do what I wanted, yes.

CABANNE: What would you do?

DUCHAMP: Oh, I don't know. I can't do a painting, or a drawing, or a sculpture. I absolutely can't. I'd have to think for two or three months before deciding to do something which would have significance. It couldn't be simply an impression, an amusement. It would have to have a direction, a sense. That's the only thing that would guide me. I'd have to find it, this sense, before I started. So if I agreed to do something, it would be with reservations.

CABANNE: Do you believe in God?

DUCHAMP: No, not at all. Don't ask that! For me, the question doesn't exist. God is a human invention. Why talk about such a Utopia?

When man invents something, there's always someone for it and some-one against it. It's mad foolishness to have made up the idea of God. I don't mean that I'm neither atheist nor believer, I don't even want to talk about it. I don't talk to you about the life of bees on Sunday, do I? It's the same thing.

Do you know the story of the Viennese school of logicians?

CABANNE: No.

DUCHAMP: The Viennese logicians worked out a system wherein every-thing is, as far as I understood it, a tautology, that is, a repetition of premises. In mathematics, it goes from a very simple theorem to a very complicated one, but it's all in the first theorem. So, metaphysics: tautology; religion: tautology: everything is tautology, except black coffee because the senses are in control!

The eyes see the black coffee, the senses are in control, it's a truth; but the rest is always tautology.

CABANNE: Do you think about death?

DUCHAMP: As little as possible. Physiologically you're obliged to think about it from time to time, at my age, when you have a headache or break your leg. Then death appears. Despite yourself, when you're an atheist, you're impressed by the fact that you're going to completely disappear. I don't want another life, or metempsychosis. It's very troublesome. It would be much better to believe in all those things, you'd die joyfully.

CABANNE: In an interview, you said that journalists' questions generally bore you to tears, but that there's one which they've never asked you and which you'd love to be asked, namely, "How are you doing?"

DUCHAMP: I'm doing very well. My health isn't at all bad. I've had one or two operations, I think normal operations at my age, like for the prostate. I've undergone the troubles which bother all seventy-nine-year-old men; watch out!

I am very happy.

Marcel Duchamp [1887-1968]

An Appreciation

The self attempts balance, descends. Perfume—the air was to stink of artists' egos. Himself, quickly torn to pieces. His tongue in his cheek.

Marcel Duchamp, one of this century's pioneer artists, moved his work through the retinal boundaries which had been established with Impressionism into a field where language, thought and vision act upon one another. There it changed form through a complex interplay of new mental and physical materials, heralding many of the technical, mental and visual details to be found in more recent art.

He said that he was ahead of his time. One guesses at a certain loneliness there. Wittgenstein said that "'time has only one direction' must be a piece of nonsense."

In the 1920s Duchamp gave up, quit painting. He allowed, perhaps encouraged, the attendant mythology. One thought of his decision, his willing this stopping. Yet on one occasion, he said it was not like that. He spoke of breaking a leg. "You don't mean to do it," he said.

The Large Glass. A greenhouse for his intuition. Erotic machinery, the Bride, held in a see-through cage—"a Hilarious picture." Its cross references of sight and thought, the changing focus of the eyes and mind, give fresh sense to the time and space we occupy, negate any concern with art as transportation. No end is in view in this fragment of a new perspective. "In the end you lose interest, so I didn't feel the necessity to finish it."

He declared that he wanted to kill art ("for myself") but his persistent attempts to destroy frames of reference altered our thinking, established new units of thought, "a new thought for that object."

The art community feels Duchamp's presence and his absence. He has changed the condition of being here.

—JASPER JOHNS

Marcel Duchamp, b. 1887
"Cross-Frame" Bicycle, 1887

The Creative Act, 1957
Recorded 1967

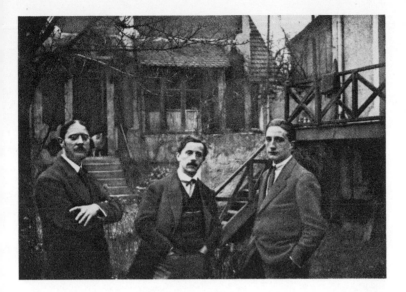

The three Duchamp brothers photographed at Puteaux in 1912. Left to right.
Jacques Villon, Raymond Duchamp-Villon, Marcel Duchamp. (Photo courtesy
The Museum of Modern Art, New York)

"La Fête à Duchamp," painted in 1917 by Florine Stettheimer. (Collection Mr. and Mrs. John D. Gordan, New York; photo Peter A. Juley & Son)

Duchamp is shown here at various stages of the party: at the upper left he waves his hand from the automobile driven by Francis Picabia, and in the left foreground he waves again as they enter the garden. At the supper table on the terrace the artist's sister Ettie proposes a toast on the right and, at the far left, Duchamp responds to it. Other guests include the artist herself, Albert Gleizes and his wife, Avery Hopwood, Leo Stein, Elizabeth Duncan, and Carl van Vechten.

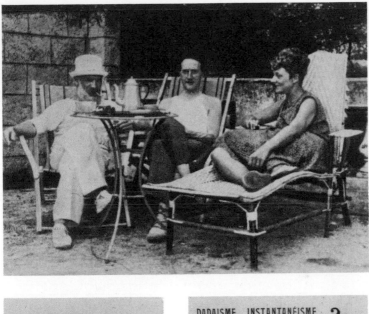

Top: Constantin Brancusi, Duchamp, and Mary Reynolds at Villefranche in 1929. (Photo reprinted from *Surrealism and Its Affinities*, Art Institute of Chicago, 1956) Bottom left: Duchamp's close friends Tristan Tzara (left) and Francis Picabia (right) in Picabia's Mercer. (From *Cannibale*, No. 2, 1920) Bottom right: Cover of *391* (no. 19, last number—October 1924), edited by Picabia, who made the portrait of Duchamp, which, according to Robert Lebel, is a photograph of Duchamp with the features of the boxer Georges Carpentier superimposed.

DOIGT — « Verse tes doigts sur mes genoux comme la trompe d'un éléphant mort. » (*Jarry*).

DOMINGUEZ (Oscar), né en 1906 — « Le dragonnier des Canaries.» Peintre surréaliste apparu en 1934.

DORTOIR — « Le dortoir de petites filles friables rectifie la boîte odieuse. » (*Cad. ex.*)

DOULEUR — « La douleur physique n'a jamais été pour nous que la cinquième roue du carrosse de la chair. » (*J. B. et P. E.*)

DUCHAMP (Marcel), né en 1887 — Peintre et écrivain pré-surréaliste et surréaliste. « Celui qui, au terme de tout le processus historique de développement du dandysme, a consenti à faire figure, comme dit Gabrielle Buffet, de « technicien bénévole », notre ami Marcel Duchamp est assurément l'homme le plus intelligent et (pour beaucoup) le plus gênant de cette première partie du XXᵉ siècle » (*A. B.*)

M. R. : Marcel Duchamp

EAU — « L'eau est une flamme mouillée » (*Héraclite*). « Fermez bien vos yeux aux forêts de pendules bleus et d'albumines violettes, en restant sourd aux suggestions de l'eau tiède. » (*Maeterlinck*). « L'eau pure de sa tête dans tes mains» (*B. P.*). « L'eau froide a les jambes nues » (*H. P.*). « devant un portrait de l'eau qui dans la baignoire laisse tomber son bras » (*P. P.*). « Tu te lèves l'eau se déplie — tu te couches l'eau s'épanouit » (*P. E.*)

ÉCREVISSE — « L'écrevisse fardée éclaire à peine différents baisers doubles. » (*Cad. ex.*)

ÉGLISE — « Tout est bien, excepté l'église... Là tout vous attriste, car l'on n'y fait rien autre que vous ruiner, vous épouvanter et vous ensevelir. » (*Baffo*).

ÉLÉGANCE — « L'élégance est un progrès. » (*Jarry*)

ÉLÉPHANT — « Les éléphants sont contagieux. » (*P. E. et B. P.*)

ELUARD (Paul), né en 1895 — « La nourrice des étoiles ». Poète surréaliste. (*Les Animaux et leurs hommes* (1920), *Les Malheurs des Immortels*, *Capitale de la douleur*, *L'Amour la poésie*, *L'Immaculée conception*, *La Vie immédiate*, *La Rose publique*, *Les Yeux fertiles*, etc., etc.)

EMBLÈME — « Concrétion souscutanée morphologique, symbolique des hiérarchies. » (*S. D.*)

ENFANT — « Le calcul des probabilités se confond avec l'enfant, noir comme la mèche d'une bombe posée sur le passage d'un souverain qui est l'homme par un anarchiste individualiste de la pire espèce qui est la femme. » (*A. B. et P. E.*). « Le miroir de chair où perle un enfant » (*P. E.*)

Max Ernst

10

Page 10 from the *Dictionnaire abrégé de Surréalisme*, published in 1938 by the Galerie Beaux-Arts in Paris. The Duchamp entry was written by André Breton and illustrated by Man Ray's 1923 portrait.

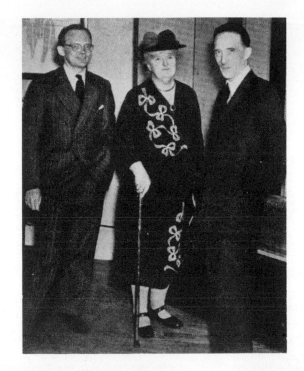

Top: George Heard Hamilton, Katherine S. Dreier, and Duchamp—the trustees and curator of the Société Anonyme collection at Yale University, photographed in New Haven in 1945. Bottom: Duchamp, Alfred Barr, and Sidney Janis (left to right) judging a competition, "The Temptation of Saint Anthony," as part of the publicity campaign for the Loew-Levin film *The Private Affairs of Bel-Ami*, 1946. The painting by Max Ernst being studied here was selected as the winner. (Photo William Leftwich)

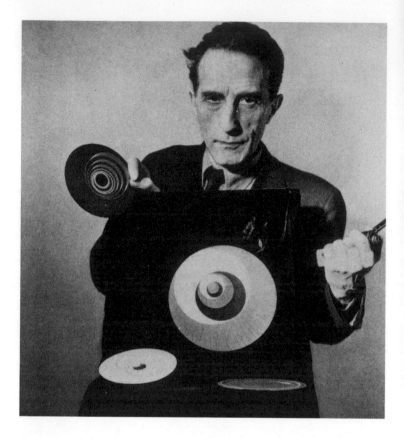

Above: Duchamp with rotoreliefs, a still from Hans Richter's film *Dreams That Money Can Buy*, 1947. (Photo Arnold Eagle)

Opposite: Duchamp in conversation photographed by Arnold Rosenberg in 1957. Duchamp came to the photographer's studio in a snowstorm to help him fulfil an assignment for a character study.

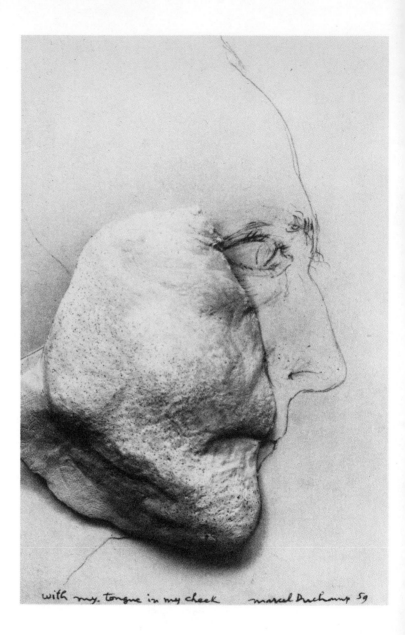

"With my tongue in my cheek"—a self-portrait by Duchamp. 1959. (Collection Robert Lebel, Paris)

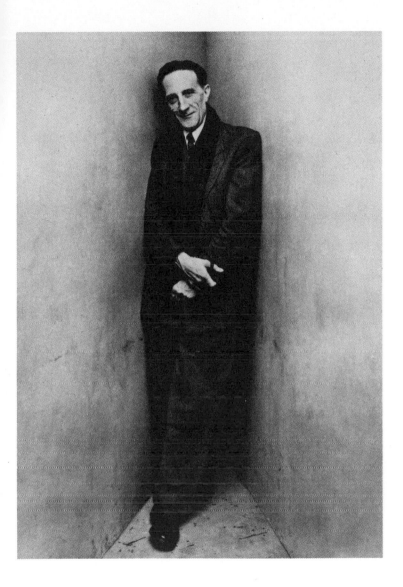

Portrait of Duchamp by Irving Penn, 1960.

IN 1913 I HAD THE HAPPY IDEA TO FASTEN A BICYCLE WHEEL TO A KITCHEN STOOL AND WATCH IT TURN.

A FEW MONTHS LATER I BOUGHT A CHEAP REPRODUCTION OF A WINTER EVENING LANDSCAPE, WHICH I CALLED " PHARMACY " AFTER ADDING TWO SMALL DOTS , ONE RED AND ONE YELLOW, IN THE HORIZON.

IN NEW YORK IN 1915 I BOUGHT AT A HARDWARE STORE A SNOW SHOVEL ON WHICH I WROTE " IN ADVANCE OF THE BROKEN ARM ".

It WAS AROUND THAT TIME, that THE WORD " READYMADE " CAME TO MY MIND TO DESIGNATE THIS FORM OF MANIFESTATION.

A POINT WHICH I (VERY MUCH) WANT TO ESTABLISH IS THAT THE CHOICE OF THESE " READYMADES " WAS NEVER DICTATED BY AN ESTHETIC DELECTATION.

THIS CHOICE WAS BASED ON A REACTION OF VISUAL INDIFFERENCE WITH AT THE SAME TIME A TOTAL ABSENCE OF GOOD OR BAD TASTE.... IN FACT A COMPLETE ANESTHESIA.

ONE IMPORTANT CHARACTERISTIC WAS THE SHORT SENTENCE WHICH I OCCASIONALLY INSCRIBED ON THE ' READYMADE '.

THAT SENTENCE INSTEAD OF DESCRIBING THE OBJECT LIKE A TITLE WAS MEANT TO CARRY THE MIND OF THE SPECTATOR TOWARDS OTHER REGIONS MORE VERBAL.

SOMETIMES I WOULD ADD A GRAPHIC DETAIL OF PRESENTATION WHICH IN ORDER TO SATISFY MY CRAVING FOR ALLITERATIONS, WOULD BE CALLED ' READYMADE AIDED '.

AT ANOTHER TIME WANTING TO EXPOSE THE BASIC ANTINOMY BETWEEN ART AND READYMADES I IMAGINED A ' RECIPROCAL READYMADE ' : USE A REMBRANDT AS AN IRONING BOARD 1.

I REALIZED VERY SOON THE DANGER OF REPEATING INDISCRIMINATELY THIS FORM OF EXPRESSION AND DECIDED TO LIMIT THE PRODUCTION OF ' READYMADES ' TO A SMALL NUMBER YEARLY. I WAS AWARE AT THAT TIME , THAT FOR THE SPECTATOR EVEN MORE THAN FOR THE ARTIST, ART IS A HABIT FORMING DRUG AND I WANTED TO PROTECT MY ' READYMADES ' AGAINST SUCH A CONTAMINATION.

ANOTHER ASPECT OF THE ' READYMADE ' IS ITS LACK OF UNIQUENESS.... THE REPLICA OF A ' READYMADE ' DELIVERING THE SAME MESSAGE, existing NEARLY EVERY ONE OF THE existing ' READYMADES ' IS NOT AN ORIGINAL IN THE CONVENTIONAL SENSE.

A FINAL REMARK TO THIS EGOMANIAC'S DISCOURSE :

SINCE THE TUBES OF PAINT USED BY THE ARTIST ARE MANUFACTURED AND READY MADE PRODUCTS WE MUST CONCLUDE THAT ALL THE PAINTINGS IN THE WORLD Are ' READYMADES AIDED ' AND ALSO WORKS OF ASSEMBLAGE.

marcel Duchamp 1961

Above: "Apropos of Readymades," text of a speech made by Duchamp in 1961 and typed by the artist. (Photo courtesy Simon Watson Taylor)

Opposite: A Dada gift from the photographer Marvin Lazarus to Duchamp. The picture was taken at the 1961 "Assemblages" exhibition at The Museum of Modern Art and later retouched by the photographer and presented to the artist.

March 12, 1962

Dear Rrose,
 Here's one on you, oui?
 Regards,
 Juan Ennui

Marvin P. Lazarus

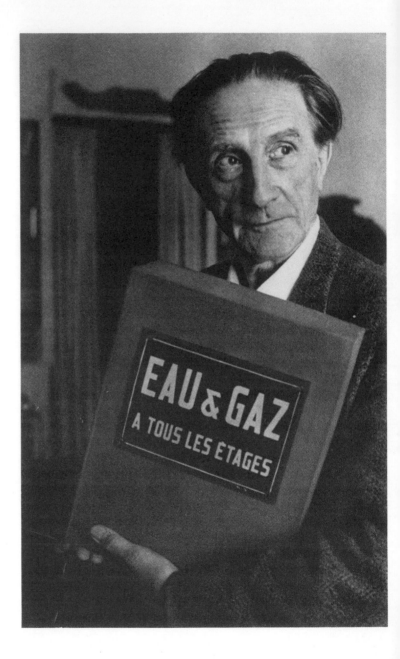

Portrait of Duchamp by Marvin Lazarus, taken at Duchamp's home in New York. April 1962.

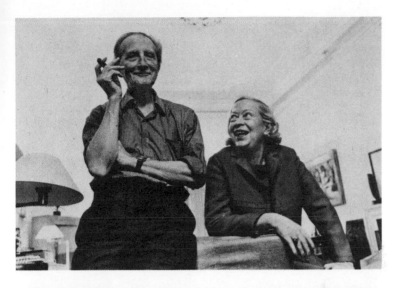

Top: Duchamp with his wife, Teeny, 1967. Bottom: Duchamp in his Greenwich Village apartment, 1967. (Photos Ugo Mulas)

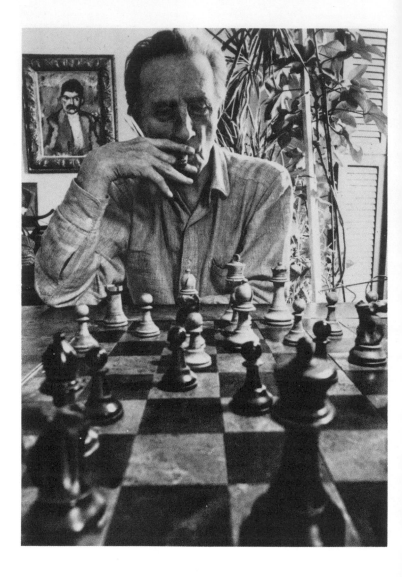

Duchamp at the chessboard, 1967. (Photo Ugo Mulas)

Richard Huelsenbeck, Duchamp, Marguerite Arp, and Marcel Jean (left to right) at the Symposium of Dada and Surrealism held in New York, 1968. (Photo Michel Sanouillet)

Étants donnés: 1e la chute d'eau. 2e le gaz d'éclairage, 1946 66. (Collection Philadelphia Museum of Art; photo A. J. Wyatt)

Chronology

1887: Born July 28 near Blainville, France.

Duchamp's grandfather was a painter: his elder brothers Jacques Villon and Raymond Duchamp-Villon, and younger sister, Suzanne, became artists.

1902: Begins painting "Landscape at Blainville," known as his first work.

1904: Graduates from the École Bossuet, the lycée in Rouen. Joins his elder brothers in Paris, where he studies painting at the Académie Jullian until July 1905.

Paints family, friends, and landscapes in post-Impressionist manner.

1905: Executes cartoons for the *Courrier Français* and *Le Rire* (continues this intermittently until 1910).

Works for a printer in Rouen. Volunteers for one year of military service.

1906: Resumes painting in Paris.

1908: Establishes a residence at Neuilly, outside Paris, until 1913.

1909: Paints (particularly portraits and nude studies) in a style deriving first from Cézanne, turning toward a free and expressionistic Fauve manner by 1910.

First exhibition (two works) at the Salon des Indépendants, Paris.

Chronology reprinted with the kind permission of Walter Hopps and Gabriel White in whose catalogues of 1963 and 1966 it was originally published.

Begins participating in Sunday gatherings of artists and poets (Apollinaire, La Fresnaye, Gleizes, etc.) at his brothers' homes in Puteaux, where he develops an awareness of Cubism.

1910: Most important "early works" executed in this year.

1911: Begins paintings related to Cubism, with emphasis on successive images of a single body in motion. Work of this type first included in exhibitions at Paris and Rouen.

Drawings and paintings related to "chess" theme.

First drawing and oil sketch of "Nude Descending a Staircase."

Executes first painting, "Coffee Mill," anticipating machine image and morphology.

1912: Climactic and virtually final year of his most important oil-on-canvas works.

Visits and paints in Munich.

"Nude Descending a Staircase," No. 2, withdrawn from the Salon des Indépendants, Paris, in furore: exhibited in public for first time at a Cubist exhibition in Barcelona: finally shown in Paris at the Salon de la Section d'Or, organized by the Duchamp brothers and their friends.

From the friendship of Duchamp, Picabia, Apollinaire, etc., there develop radical and ironic ideas to challenge the commonly held notions of art. This independent activity precedes the official founding of Dada in Zurich, 1916.

Documented in *De Cubisme* by A. Gleizes and J. Metzinger.

1913: A moment of most critical change in the artist's career. Virtually abandons all conventional forms of painting and drawing. Begins development of a personal system (metaphysics) of measurement and time-space calculation that "stretches the laws of physics just a little." Drawings become mechanical renderings. Three-dimensional objects become quasi-scientific devices, e.g., "Three Standard Stoppages," 1913–1914. Today this manifestation of "canned chance" is the artist's favorite work.

Resumes work in Paris. Employed at the Bibliothèque Sainte-Geneviève.

Begins to save and facsimile original notes and "working notations" as a unified yet random and heterogeneous entity. These collected notes from 1911–1915 (as they appear in the "Box" of 1914 and the "Green Box" of 1934) refer in a highly concentrated fashion to almost all his important work of the years ahead.

Begins work (mechanical drawings, painted studies, notations) that will culminate in his most complex and highly regarded work: "Large Glass," 1915–1923.

Conceives his first readymade, "Bicycle Wheel," which involves the infrequent special selection and mounting of commonplace objects. This establishes the first major incidence of wholly nonart elements paradoxically challenging the aesthetic frame of reference.

"Nude Descending a Staircase," No. 2, 1912, shown at the Amory Show, New York, becomes the exhibition's focus of controversy.

Publication of Guillaume Apollinaire's *Les Peintres Cubistes*, Paris: prophetic assessment of Duchamp's contribution to modern art.

1915: First visit to New York, which extends to 1918. Greeted as famous on his arrival.

Commences his lifelong friendship with Walter and Louise Arensberg and many American poets and artists, particularly Man Ray.

Establishes a studio and begins work on the "Large Glass" itself. Included in an exhibition at the Carroll Gallery, New York (first appearance in a private gallery).

"A Complete Reversal of Art Opinions by Marcel Duchamp, Iconoclast," *Arts and Decoration* (September), New York. First published statement.

1916: Founding member of the Society of Independent Artists, Inc., New York.

1917: Assists in first exhibition of Society of Independent Artists: resigns upon rejection of "Fountain," submitted under the pseudonym "R. Mutt." With Picabia, Man Ray, and Jean Crotti, his support of Dada prompts Arensberg and H. P. Roché to publish reviews: *The Blind Man* and *Rongwrong*.

1918: With execution for Katherine Dreier of "*Tu m'*," his first oil painting in four years, Duchamp gives up painting completely.

Moves to Buenos Aires, where he continues his creative activity for nine months.

1919: Returns to Paris. Stays with Picabia, establishing contact with Dada group including Ribemont-Dessaignes, Pierre de Massot, Jacques Rigaud, etc.

1920: Includes "*L.H.O.O.Q.*" in first uproarious public demonstration of Dada in Paris.

Assumes pseudonym of Rrose Sélavy, which he applies henceforth to published writings and readymades.

Completes "Rotary Glass Plate (Precision Optics)," his first motor-driven construction.

With Katherine Dreier, conceives and founds the Société Anonyme, an international permanent collection of modern art from which they hoped to establish a museum. The pioneering activity of this organiz-

ation presented eighty-four exhibitions by 1939, as well as numerous lectures and publications. In 1941 the Dreier collection was presented to Yale University Art Gallery.

1921: With Man Ray, edits and publishes one issue of *New York Dada*, including contributions by Tristan Tzara and Rube Goldberg.

Continues work on optical devices as well as readymades.

Spends six months in Paris with Jean and Suzanne (Duchamp) Crotti.

1922: Returns to New York to continue work on the "Large Glass."

Publication of "Marcel Duchamp" by André Breton in his *Littérature*, No. 5 (October) Paris.

Experiments in the secret truth of numbers, applied to games. Resumes passion for chess.

1923: Ceases work on the "Large Glass," having brought it to a "state of incompletion."

Returns to Paris where he remains until 1926, save for occasional trips around Europe.

The idea reaches the public that Duchamp has "ceased to produce art."

1924: Produces a roulette system whereby one "neither wins nor loses."

Appears with Erik Satie, Man Ray, and Picabia in René Clair's film *Entr'acte* and in the only performance of the ballet *Relâche*, by Picabia and Satie, at the Théâtre des Champs Élysées.

1925: Participates in chess tournament, Nice. Travels through Italy.

In Paris, completes second optical instrument, "Rotary Demisphere."

1926: Incorporates optical experiments into *Anemic Cinema*, filmed in collaboration with Man Ray and Marc Allegret.

Begins speculative purchases and sales of art works, an activity ironically counter to his lifelong aversion to the usual commercial aspects of art.

Visits New York briefly to arrange a Brancusi exhibition at the Brummer Gallery.

The "Large Glass" exhibited for the first time at the International Exhibition of Modern Art at the Brooklyn Museum, organized by the Société Anonyme. This work accidentally shattered following the exhibition. Its condition remained undiscovered until the work was removed from storage several years later.

Work included in the second collective Surrealist exhibition at La Galerie Surréaliste, Paris.

1927: First marriage to Lydie Sarrazin-Levassor.

1929: Visits Spain with Katherine Dreier.

1933: Brief visit to New York to organize a second Brancusi exhibition at Brummer Gallery.

1935: Publication of André Breton's *"Phare de la Mariée"* ("Lighthouse of the Bride") in *Minotaure*, No. 6, Paris—the first comprehensive and a most important essay on Duchamp's major work.

1936: Four works included in the big international Surrealist Exhibition, London.

Eleven works (largest selection to this time) included in "Fantastic Art, Dada, Surrealism," a vast exhibition with a comprehensive catalogue prepared by Alfred Barr at the Museum of Modern Art, New York.

Visits New York to undertake the painstaking restoration of the "Large Glass."

1937: First one-man show given at the Arts Club of Chicago (nine works included).

1938: Participates in the organization of the International Surrealist Exhibition, Galerie des Beaux-Arts, Paris, with Breton, Eluard, Dali, Ernst, Man Ray, and Paalen.

Begins his limited edition of the "Box in a Valise " issued 1938–1941, a portable museum with his important works grouped in miniature reproductions.

1942: Returns to New York, where he collaborates with Breton, Sidney, Janis, and R. A. Parker on the "First Papers of Surrealism" exhibition and catalogue.

1944: First independent exhibition of the Duchamp brothers at Yale University Art Gallery.

1945: Special Marcel Duchamp number of *View* (March), New York.

1946: In Paris, where he and Breton design and prepare "Le Surréalisme en 1947" exhibition.

Duchamp returns to New York before the opening.

1949: "Twentieth Century Art from the Louise and Walter Arensberg Collection." An exhibition at the Art Institute of Chicago (thirty works by Duchamp included).

1950: Critical studies (written between 1943 and 1949) contributed to the catalogue of the collection of the Société Anonyme, Yale University Art Gallery.

1951: Publication of *The Dada Painters and Poets: An Anthology*, edited by Robert Motherwell; Wittenborn Schultz Inc., New York. Includes contributions by and about Duchamp.

1952: "Duchamp Brothers and Sister": an exhibition at the Rose Fried Gallery, New York.

1954: Marries Alexina (Teeny) Sattler.

Opening of a permanent exhibition of the Walter and Louise Arensberg Collection at the Philadelphia Museum of Art, which received this vast bequest in 1950; forty-three works by Duchamp included. Comprehensive catalogue published.

1957: Major exhibition and catalogue of the Duchamp brothers at the Solomon R. Guggenheim Museum, New York, prepared by James Johnson Sweeney.

1958: *Marchand du Sel, Écrits de Marcel Duchamp*, compiled by Michel Sanouillet, Le Terrain Vague, Paris: the most comprehensive collection of Duchamp's writings and statements.

1959: Assists in the design and publication of *Sur Marcel Duchamp* by Robert Lebel, Trianon Press, Paris; English translation by George Heard Hamilton, Grove Press, New York. The most comprehensive and definite work on Duchamp to date. Includes a catalogue raisonné of two hundred and eight detailed entries and an extensive bibliography. This publication celebrated in one-man exhibitions at the Sidney Janis Gallery, New York, and Galerie La Hune, Paris.

Helps arrange the "Exposition Internationale du Surréalisme," Galerie Daniel Cordier, Paris.

1960: Publication of *The Bride Stripped Bare by Her Bachelors, Even*, a typographic version of the "Green Box," by Richard Hamilton; Lund Humphries, London.

Featured in an exhibition at the Galleria Schwarz, Milan.

1961: Featured in "Art of Assemblage" exhibition and catalogue by William Seitz, the Museum of Modern Art, New York.

Interview with Richard Hamilton on Monitor, BBC television.

Featured in "Rörelse I Könsten" exhibition and catalogue at the Moderna Museet, Stockholm, as a pioneer in the conception of motion in art.

"Large Glass" replica made by Ulf Linde, Stockholm.

Dissertation by Lawrence D. Steefel, Jr.: "The Position of *La Mariée mise à nu par ses Célibataires, même* (1915–1923) in the Stylistic and Iconographic Development of Marcel Duchamp," Princeton.

1962: Publication of a major article by Lawrence D. Steefel, Jr.: "The Art of M.D.," *The Art Journal*, XXII, No. 2 (Winter 1962–1963), New York.

1963: One-man exhibition at Galerie Burén, Stockholm, in conjunction with the publication of a major monograph, *Marcel Duchamp*, by Ulf Linde.

"Duchamp, Picabia, Schwitters," an exhibition at the Alan Gallery, New York.

First major retrospective exhibition, "By or of Marcel Duchamp or Rrose Sélavy," arranged by Walter Hopps at the Pasadena Art Museum, one hundred and fourteen items.

1964: Galleria Schwarz, Milan, produces thirteen readymades in editions of eight signed and numbered copies. One-man exhibition at the Galleria Schwarz followed by European tour. Lavish catalogue.

Jean-Marie Drot makes a film, *Game of Chess with Marcel Duchamp*, for French television, which wins first prize at the Bergamo Film Festival.

1965: "Not seen and/or Less Seen of/by Marcel Duchamp/Rrose Sélavy," exhibition at Cordier and Ekstrom, Inc., New York, of the Mary Sisler collection. Ninety items, many previously not exhibited. Catalogue introduction and notes by Richard Hamilton.

Profiled in *The New Yorker* by Calvin Tomkins.

The New Yorker article, plus three others on Cage, Tinguely, and Rauschenberg, published as *The Bride and the Bachelors*, Weidenfeld and Nicolson, London, and Viking, New York.

1966: "Large Glass" reconstructed, together with studies, in the University of Newcastle upon Tyne by Richard Hamilton. Exhibited, May, as "The Bride Stripped Bare by Her Bachelors, Even, Again." Photo-reportage catalogue.

Tristram Powell makes a film, *Rebel Ready-made*, for BBC television. Shown on "New Release" (BBC-2, 23 June).

The Tate Gallery shows the first major retrospective held in Europe, June 13–July 31. Sponsored by the Arts Council.

Arts and Artists (*London*) publishes special Duchamp number, July 1966.

Newly discovered notes by Duchamp (1912–1920) published as *À l'Infinitif* by Cordier & Ekstrom, New York.

1967: The Mary Sisler Collection exhibited by the City of Auckland Art Gallery, April, and the Australian State Galleries, 1967–1968.

Entretiens avec Marcel Duchamp by Pierre Cabanne published in Paris.

Arturo Schwarz, Milan, publishes *The Large Glass and Related Works* with original etchings by Marcel Duchamp.

New edition of Robert Lebel's *Marcel Duchamp* issued by Grossman Publishers, New York, with revised catalogue.

1968: The Museum of Modern Art holds major retrospective, "Dada, Surrealism and Their Heritage," March 27–June 9, directed by William Rubin.

Marcel Duchamp dies in his studio in Neuilly, Paris, October 1.

"The Machine" at the Museum of Modern Art, New York, exhibits pioneer work of Marcel Duchamp, November 25, 1968–February 9, 1969.

1969: Arturo Schwarz publishes two major works for Abrams, New York: *Marcel Duchamp—Notes and Projects for the Large Glass* and a monumental monograph: *The Complete Works of Marcel Duchamp.*

1971: *Conversations with Marcel Duchamp* by Pierre Cabanne issued in translation by Viking, New York, and Thames and Hudson, London.

Selected Bibliography

Note to the Reader

Several major bibliographies on Marcel Duchamp have been published very recently, although his associates in the Société Anonyme (bibl. 52*) put together a useful list as early as 1950. Since these volumes are accessible and comprehensive, even authoritative and almost exhaustive, it does not seem appropriate on the present occasion to attempt a monumental consolidation of that data. Instead, the record below is selective and, in keeping with this edition, emphasizes the English material under the following sections:

Major Texts by Duchamp (bibl. 1–9)
Selected Items by Duchamp (bibl. 10–25)
About Duchamp: Books, Brochures, Catalogues (bibl. 26–51)
Selected Periodical References (bibl. 52–65)
Selected Bibliography (bibl. 66–72)

By having his attention drawn to the main bibliographies and monographs, significant articles and catalogues, the researcher, without being overwhelmed by detail, is immediately in command of the known documentation. Important addenda since the admirable commentary of Robert Lebel (bibl. 69), Poupard-Lieussou (bibl. 70), and Arturo Schwarz (bibl. 71) are incorporated without enumerating the European

citations. Moreover, these can be easily traced in *The Art Index* and their continental equivalents.

Special mention must be made of the courtesy of Walter Hopps and Gabriel White in allowing their chronology on Marcel Duchamp, a major biographical document, to be reprinted (p. 113).

<div align="right">

BERNARD KARPEL
Librarian
Museum of Modern Art
New York

</div>

Major Texts by Duchamp

1. DUCHAMP, MARCEL. *À l'Infinitif.* New York, Cordier & Ekstrom, 1966.

 Facsimile reproductions of new 1912–1920 notes now in the Mary Sisler collection. Edition de luxe, also called the *White Box*, includes English translations. Partially published in works cited in bibl. 8, 17.

2. ———. "Apropos of 'Readymades,'" *Art and Artists*, July 1966, p. 47.

 Signed 1961, prepared for "Assemblage" symposium of Museum of Modern Art, October 1961. Introduced by Simon Watson Taylor article, p. 46. Also note bibl. 7.

3. ———. *The Bride Stripped Bare by Her Bachelors, Even.* A typographical version by Richard Hamilton of Duchamp's *Green Box*. Translated by George Heard Hamilton. New York, Wittenborn; London, Percy Lund, Humphries, 1960.

 "This version of the *Green Box* is as accurate a translation of the meaning and form of the original notes as supervision of the author can make it." [Marcel Duchamp.] Appendices: "Inside the 'Green Box'" by G. H. Hamilton. Diagram by R. Hamilton. "The Green Box" by R. Hamilton.

4. ———, with Pierre Cabanne. *Dialogues with Marcel Duchamp.* New York, Viking, 1970.

 Translation of Pierre Cabanne, *Entretiens avec Marcel Duchamp,* Paris, Editions Pierre Belfond, 1967. Reviewed by Jean Clay, *International Studio,* November 1967, pp. 241–242.

5. ———. *From the Green Box.* New Haven, Readymade Press, 1957. Translated with preface by George Heard Hamilton. Twenty-five notations from the 1934 edition of ninety documents relating to the conception of his large painted glass, *La Mariée mis à nu par ses Célibataires, même,* presented for the first time in English. "I avoided those documents which dealt with the Bride and chose those for the readymades." [Translator's note]

6. ———. *Marchand du Sel. Écrits de Marcel Duchamp réunis et présentés par Michel Sañouillet.* Paris, Le Terrain Vague, 1958.

Primarily a French anthology, it includes fragments and longer passages in English and, most conveniently and in alphabetical order, all the critiques for the Société Anonyme catalogue (Yale, 1950), pp. 117–148. Comprehensive and annotated bibliography by Poupard-Lieussou lists all details to date associated with this complete anthology of both extensive and brief statements.

6a. ———. *Notes and Projects for the Large Glass.* Selected, ordered, and with an introduction by Arturo Schwarz. New York, Abrams, 1969.

Facsimile of Duchamp's notes (1912–1914) with English translations. Bibliographical notes, pp. 9–10. Also note edition de luxe (Milan, 1967) in bibl. 45.

7. ———. "Passport No. G. 255300." [An interview by Otto Hahn.] *Art and Artists*, July 1966, pp. 7–11. Note bibl. 2, p. 47. For other interviews see following citations; for example, bibl. 10, 27, 53a, etc.

8. ———. "Speculations." *Art in America*. March–April 1966.

Notes from 1912 to 1920. A selection arranged for publication here in advance of full facsimile reproduction in *À l'Infinitif* (New York, Cordier & Ekstrom). Prefatory note by Cleve Gray, translator. Illustrations and photos (no. 2, pp. 72–75). Also recording (bibl. 17).

9. ———. [Statements on Artists in the Collection]. In Yale University Art Gallery. Collection of the Société Anonyme. New Haven, Conn., Associates in Fine Arts at Yale University, 1950.

Brief biographies and critiques, printed passim, on thirty-two artists. Texts, written 1943–49, also published in *Marchand du Sel* (bibl. 6), pp. 116–148.

Selected Items by Duchamp

10. ASHTON, DORE. "An Interview with Marcel Duchamp." *Studio International*, June 1966. On the occasion of the Tate Gallery exhibition.

11. *The Blind Man.* New York, 1917.

No. 1, April 10, 1917, published by Henri Pierre Roché; no. 2, May 1917, published by Beatrice Wood. Apparently only no. 2 was issued with distinct Duchamp material: the cover ("Chocolate Grinder"), reproduction of urinal ("Fountain by R. Mutt"), text titled "The Richard Mutt Case." Eleven named contributors and "perhaps also by Man Ray and Marcel Duchamp" (Lebel, reference 2).

12. CAMFIELD, WILLIAM ARNETT. "La Section d'Or." New Haven, Yale

University, 1961. Unpublished M.A. thesis. Appendix C includes interview with Marcel Duchamp and letters. General bibliography.

13. DUCHAMP, MARCEL. "The Bride Stripped Bare by Her Bachelors, Even." *This Quarter*, September 1932, pp. 189–192.

"Translation by J. Bronowsky of some of Duchamp's notes later published in the *Green Box*. Preface by André Breton, guest editor for special Surrealist number.

14. ———. "A Complete Reversal of Art Opinions by Marcel Duchamp, Iconoclast." *Arts and Decoration*, September 1915, pp. 427–428, 442.

Possibly not so titled by the artist but probably a fair reflection of his views.

15. ———. "The Creative Act." In *The New Art, A Critical Anthology*, edited by Gregory Battcock. New York, Dutton, 1966, pp. 23–26.

A paper read to the annual convention of the American Federation of Arts (Houston, Texas, April 1957). Also issued as a 33⅓ rpm record for *Aspen* magazine (New York), no. 5-6, section 13 and verso: "Some texts from *À l'Infinitif* (1912–1920)." (Recorded by the author, November 1967 in New York).

15a. ———. "I propose to strain the laws of physics." *Art News*, December 1968, pp. 46–47, 62–64.

Interview with Francis Roberts.

16. ———. [Replies to Daniel MacMorris]. *Art Digest*, January 1, 1938, p. 22. Quotes Duchamp, as recalled by MacMorris, whose portrait of the artist is reproduced, p. 22.

16a. ———. "Some late thoughts of Marcel Duchamp." *Arts (New York)*, December 1968–January 1969, pp. 21–22.

From an interview with Jeanne Siegal. Condensation of WBAI-FM broadcast, April 1967, in series "Great Artists in America Today."

17. ———. [33⅓ rpm recording.] New York, Aspen, November 1967. "Recorded by the author." Issued as insert in *Aspen* magazine (New York), no. 5-6, section 13. Includes "The Creative Act" (bibl. 15) and verso: "Some texts from *À l'Infinitif* (1912–1920)" (bibl. 1, 8).

18. KUH, KATHERINE. "Marcel Duchamp." In *The Artist's Voice: Talks with Seventeen Artists*. New York, Harper & Row, 1962.

Includes brief chronology.

19. MACAGY, DOUGLAS, ed. *The Western Round Table on Modern Art*. Abstract of Proceedings. San Francisco, San Francisco Art Association, 1949.

A mimeographed report of about twenty per cent of the proceedings in which George Boas, Robert Goldwater, Mark Tobey, Andrew Ritchie, F. L. Wright, and others participated. Duchamp quoted or

mentioned: pp. 7–9, 20, 23, 26–27, 30, 32, 43, 49, 50, 60–61, 65–66. Conference also partly published in *Modern Artists in America* (bibl. 20). Editor says almost all Duchamp remarks were reprinted.

20. MOTHERWELL, ROBERT, *et al. Modern Artists in America*. First series. Edited by Robert Motherwell, Ad Reinhardt, Bernard Karpel. New York, Wittenborn, Schultz, 1951.

Includes *The Western Round Table on Modern Art*, pp. 25–37 (bibl. 19).

21. NELSON, JAMES, ed. *Wisdom: Conversations with the Elder Wise Men of Our Day*. Edited and with an introduction by James Nelson. New York, Norton, 1958.

Includes Marcel Duchamp, Walter Gropius, Jacques Lipchitz, Edward Steichen, Frank Lloyd Wright, etc. Bibliographies.

22. PARINAUD, ANDRÉ. *André Breton—Entretien avec Marcel Duchamp*. In *Omaggio a André Breton*. Milan, Galleria Schwarz, January 17–February 11, 1967.

Italian, French, English text. Essay and homage with frequent quotations from Duchamp. Breton bibliography by Arturo Schwarz.

23. SEITZ, WILLIAM C., ed. *Art of Assemblage Symposium*. New York, Museum of Modern Art, 1961.

Panel: Roger Shattuck, Charles R. Huelsenbeck, Marcel Duchamp, Robert Rauschenberg, Lawrence Alloway. Moderator: William C. Seitz. Held in conjunction with exhibition, October 19, 1961. Taped and typed transcript.

24. SEITZ, WILLIAM, "What's happened to art?" An interview with Marcel Duchamp on present consequences of New York's 1913 Armory show. *Vogue* (New York) March 1, 1963.

An edited taped interview (pp. 110–113, 129–131).

25. SWEENEY, JAMES JOHNSON. [Interview with Marcel Duchamp.] *Museum of Modern Art Bulletin* (New York), No. 4–5, 1946.

Special issue: "Eleven Europeans in America." Brief biography and bibliography. Supplemented by 1956 interview, a Duchamp-Sweeney kinescope, in television archive of the museum.

About Duchamp: Books, Brochures, Catalogues

26. ARTS COUNCIL OF GREAT BRITAIN. *The Almost Complete Works of Marcel Duchamp at the Tate Gallery*. London, June 18–July 31, 1966.

Preface and chronology by Gabriel White; introduction by Richard Hamilton. Annotated illustrated catalogue including books, periodicals, documents. Extensive bibliography by Arturo Schwarz.

27. BARR, ALFRED H., JR. *Fantastic Art, Dada, Surrealism*, 4th ed. New York, Museum of Modern Art and the Arno Press (1969).

A reprint of a classic exposition. Exhibition catalogue (December 1936), reissued with essay by Georges Hugnet (1937) and revised for trade edition by Simon and Schuster, with chronology and bibliography but omitting catalogue. Reprint by Arno (identical data but converts color into black and white). In original exhibition (December 7–January 17), nos. 216–225e were by Marcel Duchamp.

28. CHICAGO ART INSTITUTE. *20th Century Art from the Louise and Walter Arensberg Collection*. Chicago, October 20–December 18, 1949.

Essay by Katherine Kuh on Marcel Duchamp. Also consult James Thrall Soby: "Marcel Duchamp in the Arensberg Collection," *View* (New York), March 1945.

29. CORDIER & EKSTROM, INC. Not Seen and/ or Less Seen of/ by Marcel Duchamp/ Rrose Sélavy 1904–1964. Mary Sisler Collection, New York, January 14–February 19, 1965.

Foreword and catalogue texts by Richard Hamilton. Also exhibited at the Milwaukee Art Center, with similar catalogue, September 9–October 3. Exhibits include documents and editions.

30. DREIER, KATHERINE S., AND MATTA, ECHAURREN. *Duchamp's Glass: La Mariée mise à nu par ses Célibataires, même*. An analytical reflection. New York, Société Anonyme, 1944.

31. FASSIO, JUAN ESTABAN. [Projected bibliography of Marcel Duchamp. Buenos Aires, 197?].

Reported by Robert Lebel (bibl. 69), p. 183, as in progress.

32. GERSHMAN, HERBERT S. *The Surrealist Revolution in France*. Ann Arbor, University of Michigan Press, 1969.

Duchamp references, p. 251 (index). Appendices include a chronology (last entry: "Marcel Duchamp dies October 1"). The companion volume is the bibliography (bibl. 67).

GUGGENHEIM. See bibl. 47.

33. HAMILTON, RICHARD. *The Bride Stripped Bare by Her Bachelors, Even, Again*. Newcastle upon Tyne, Department of Fine Art, University of Newcastle, 1966. A second construction of the "Large Glass," by Hamilton. (The first was by Ulfe Linde, Stockholm, 1961.)

34. HOPPS, WALTER, *et al. Marcel Duchamp Ready-Mades, etc. (1913–1964)*. Essays by Walter Hopps, Ulfe Linde, Arturo Schwarz. Milan, Galleria Schwarz, 1964.

Texts in Italian, French, and English. Chronology and catalogue. Published on the occasion of Duchamp exhibition, June 5–September 30.

45. HULTEN, K. G. PONTUS. *The Machine as Seen at the End of the Mechanical Age.* New York, Museum of Modern Art, 1968.

Published on the occasion of an exhibition, November 25, 1968– February 9, 1969. Major works by Duchamp; for text see p. 212 (index). Also shown at University of St. Thomas, Houston; San Francisco Museum of Art. Extensive notes and general bibliography.

46. JEAN, MARCEL. *The History of Surrealist Painting.* London, Weidenfeld & Nicolson; New York, Grove Press, 1960.

Arpad Mezei, collaborator, Simon Watson Taylor, translator. First edition: Paris, Editions de Seuil, 1959. Duchamp references, p. 379 (index).

47. LEBEL, ROBERT. *Marcel Duchamp.* With chapters by Marcel Duchamp, André Breton, and H. P. Roché. Translation by George Heard Hamilton. New York, Grossman Publishers, 1967.

Reprint edition without colorplates; otherwise unabridged and with addenda to the catalogue. First French edition: *Sur Marcel Duchamp* (Paris, Trianon, 1959). American edition 1959. Foreword to reprint edition, 1967. Text by Duchamp; "The Creative Act"; by Roché; "Souvenirs of Marcel Duchamp"; by Breton, "Lighthouse of the Bride." Of major significance is the illustrated catalogue raisonné and extensive bibliography.

47a. LINDE, ULF. *Marcel Duchamp.* Stockholm, Galerie Burén, 1963. Text in Swedish (65 pp., illus.). Also note bibl. 34.

48. MAN RAY. *Self-Portrait.* Boston, Toronto; Little, Brown, 1963.
References to Duchamp *passim*; no index.

49. MCBRIDE, HENRY. *Florine Stettheimer.* New York, Museum of Modern Art, 1946.

Duchamp included in group and portrait paintings (New York, 1917–1923).

50. MOTHERWELL, ROBERT, ed. *The Dada Painters and Poets.* New York, Wittenborn, Schultz, 1951 (reprinted 1967).

Includes articles by Breton, Buffet, Janis on the artist. Duchamp references and illustrations, p. 385 (index). Extensive general bibliography by Bernard Karpel, not updated in reissue.

51. PACH, WALTER. *Queer Thing, Painting: Forty Years in the World of Art.* New York and London, Harper, 1938, p. 332 (index).

52. PASADENA ART MUSEUM. *Marcel Duchamp, a Retrospective Exhibition.* Pasadena, October 8–November 3, 1963.

"Largest comprehensive exhibition to date." Reproduces Lebel catalogue "corrected" by Walter Hopps, director. Also his preface and chronology. Brief Duchamp quotes.

42a. PAZ, OCTAVIO. *Marcel Duchamp.* Mexico, D.F., Ediciones Era, 1968. Six parts in small folio. Two booklets including essay by Paz (62pp., illus.), and translated *Textos* by Duchamp (69pp., illus). Also reproduction of the "Large Glass" and three colorplates (from the Arensberg Collection), an envelope with postcard size reproductions, and an *álbum fotográfico,* i.e., portraits, chronology, and mss. facsimile.

42b. PAZ, OCTAVIO. *Marcel Duchamp or The Castle of Purity.* London, Cape Goliard; New York, Grossman, 1970.

Translated from the Spanish by Donald Gardner. French limited edition issued in 1967 by Claude Givaudan, Paris.

42c. ROCHÉ, HENRI-PIERRE. "Marcel Duchamp." pp. 104–105, in *Dictionary of Modern Painting.* New York, Tudor, 1955.

Originally *Dictionnaire de la Peinture moderne* (Paris, Hazan, 1954). Supplemented by "Souvenirs of Marcel Duchamp" (bibl. 36).

42d. RUBIN, WILLIAM. *Dada and Surrealist Art.* New York, Abrams, 1969. Duchamp, p. 516 (extensive index); bibliography pp. 501–502.

43. RUBIN, WILLIAM. *Dada, Surrealism and Their Heritage.* New York, Museum of Modern Art, 1968.

Edited by Irene Gordon. Chronology, bibliography. Duchamp, p. 245 (index). Also see Rubin, "Reflections on Marcel Duchamp," *Art International,* November 1960.

44. SCHWARZ, GALLERIA. *Duchamp Ready-Mades, etc.* (*1913–1964*). Milan, June 5–September 30, 1964.

For complementation, see catalogue brochures of the Galleria Schwarz, edited by Arturo Schwarz, e.g., September 1954–November 1967: *Original Signed and Numbered Editions,* etc., December 1964, no. 52: *1954–1964: Ten Years of Numbered Editions*; November 1967, no. 75: *The Large Glass and Related Works,* etc.

45. SCHWARZ, ARTURO. *The Large Glass and Related Works, with Nine Original Etchings by Marcel Duchamp.* Milan, Schwarz Gallery, 1967.

Limited edition of 135 copies. Includes "144 facsimile reproductions of Duchamp's notes (with parallel English translation) and preliminary studies for the Large Glass." Also see bibl. 6a.

46. SCHWARZ, ARTURO. The Complete Works of Marcel Duchamp. New York, Abrams, 1969. 630 pp., 765 illus. (75 col.)

Includes critical catalogue raisonné, and exhaustive descriptive bibliography. Bibl. 6a issued simultaneously with companion volume.

47. SOLOMON R. GUGGENHEIM MUSEUM. *Jacques Villon, Raymond Duchamp-Villon, Marcel Duchamp.* New York, January 8–February 17, 1957.

Section devoted to Duchamp includes biography, bibliography, and

André Breton: "Lighthouse of the Bride" (from bibl. 65). Exhibited also at Houston, March 8–April 8.

48. STEEFEL, LAWRENCE D., JR. "The Position of '*La Mariée mise à nu par ses Célibataires, même*' (*1915–1923*) in the Stylistic and Iconographic Development of Marcel Duchamp." Princeton, N.J., Princeton University, 1960.

A doctoral dissertation. Extensive notes. Available from University Microfilms, Ann Arbor, Mich., as microfilm or Xerox book.

49. TOMKINS, CALVIN. *The Bride and the Bachelors: The Heretical Courtship in Modern Art*. New York, Viking, 1965; revised edition, 1968.

Texts on John Cage, Marcel Duchamp, Robert Rauschenberg, and Jean Tinguely which, somewhat modified, appeared in *The New Yorker* (see bibl. 64). New introduction.

50. TOMKINS, CALVIN. *The World of Marcel Duchamp, 1887—*, by Calvin Tomkins and the Editors of Time-Life Books. New York, Time, Inc., 1966.

Chronology, bibliography.

51. VIEW MAGAZINE. *Marcel Duchamp Number*. New York, View Editions, 1945.

De luxe edition in boards of special issue, March 1945; covers by the artist. (One hundred copies, signed reproductions, signatures of contributors.) Includes "Lighthouse of the Bride" by André Breton (from *Minotaure*); essays by J. T. Soby, G. Buffet, H. and S. Janis, F. J. Kiesler, etc.

52. YALE UNIVERSTIY ART GALLERY. *Collection of the Société Anonyme: Museum of Modern Art, 1920*. New Haven, Conn., Associates in Fine Arts at Yale University, 1950.

Collection presented by Katherine Dreier and Marcel Duchamp, trustees. Numerous "statements" by Duchamp on artists in the collection, also published in *Marchand du Sel* (bibl. 6). Catalogue edited by George Heard Hamilton. Includes section on Duchamp with bibliography, pp. 148–150. Bibliographical contributions by Bernard Karpel *passim*.

52a. ZURICH KUNSTGEWERBEMUSEUM. *Dokumentation über Marcel Duchamp*. Zurich, 1960.

Exhibited June 30–August 28, with texts by H. Fischli, Max Bill, Marcel Duchamp, biography by S. Stauffer.

Selected Periodical References

53. ART AND ARTISTS MAGAZINE. [*Hommage à Marcel Duchamp*]. New York, July 1966.

Special issue, v. 1, no. 4, edited by Mario Amaya, with English and some French contributions. Includes interview with Richard Hamilton on reconstruction of the "Large Glass" for the Tate retrospective.

53a. ART IN AMERICA MAGAZINE. [Marcel Duchamp, 1887–1968.] July 1969.

Contributions by C. Gray, J. Johns, N. Calas, W. Copley, H. Richter; also includes chronology by W. Hopps, conversation with Calder, interview with D. Norman, C. Roberts (v. 57, pp. 20–43).

54. BRETON, ANDRÉ. "Lighthouse of the Bride." 1935.

Originally *"La Phare de la Mariée"* in *Minotaure*, no. 6, 1935. Translated in *View*, 1945 (bibl. 51), and reprinted in the Guggenheim catalogue, 1957 (bibl. 47), and also in R. Lebel (bibl. 37).

54a. D'HARNONCOURT, ANNE, and HOPPS, WALTER: *Étant Donnés: 1° la chute d'eau, 2° le gaz d'éclairage.* Reflections on a new work by Marcel Duchamp. *Philadelphia Museum of Art Bulletin*, nos. 299–300 April–September 1969.

Preface by Evan H. Turner. Extensive notes.

55. HAMILTON, RICHARD. "Duchamp." *Art International*, January 1964.

Also note bibl. 33. Supplemented by "In Duchamp's Footsteps," *Studio International*, June 1966, which illustrates Hamilton's reconstruction of the "Large Glass," 1915–1923; captions by Andrew Forge.

56. JANIS, HARRIET, and JANIS, SIDNEY. "Marcel Duchamp, Anti-artist." *Horizon* (London), October 1945.

Also in *View*, Duchamp number (bibl. 51, 65), and *The Dada Painters and Poets* (bibl. 40).

57. JOHNS, JASPER. "Marcel Duchamp (1887–1968)." *Artforum*, v. 7, no. 3, November 1968.

58. KENEAS, ALEXANDER. [Marcel Duchamp: the grand dada]. *New York Times*, Oct. 2, 1968, pp. 1, 51.

Comprehensive obituary reporting death Oct. 1. Quotes Duchamp. Also brief appraisal by John Canaday.

59. KRASNE, BELLE. "A Marcel Duchamp Profile." *Art Digest*, January 15, 1952.

60. ROCHÉ, HENRI-PIERRE. "Marcel Duchamp." pp. 104–105. In *Dictionary of Modern Painting*, New York, Tudor, 1955.

Originally *Dictionnaire de la Peinture Moderne* (Paris, Hazan, 1954). Supplemented by "Souvenirs of Marcel Duchamp" (bibl. 37.)

61. SARGEANT, WINTHROP. "Dada's Daddy." *Life* (New York), April 28, 1952.

"A new tribute is paid to Duchamp, pioneer of nonsense and nihilism." Supplemented by article on "The Great Armory Show of 1913," January 3, 1950.

62. SCHWARZ, ARTURO. "The mechanics of 'The Large Glass.'" *Cahiers Dada, Surréalisme* (Paris), no. 1, 1966.

Illustrated by two Duchamp etchings and one diagram from publications of the Galleria Schwarz, Milan. Article also in *Art International*, Summer 1966.

63. STEEFEL, LAWRENCE D., JR. "The Art of Marcel Duchamp." *Art Journal* (New York) v. 22, no. 2, Winter 1962–1963.

Portion of doctoral dissertation (Princeton, 1960), bibl. 48.

64. TOMKINS, CALVIN. "Profiles: Marcel Duchamp: Not Seen and or Less Seen." *The New Yorker*, February 6, 1965.

Quotes the artist frequently. Scattered pages, p. 37 ff. (37–40, 42, 44, 47–48, 50, 55–56, 58, 60, 62, 65–66, 68, 70, 72, 75–76, 78, 80, 82, 87–90, 93). Reprinted in *The Bride and the Bachelors* (bibl. 49).

65. VIEW MAGAZINE. [Marcel Duchamp Number.] March 1945.

Special issue, series v, no. 1. Articles by Breton, Buffet, Janis, Kiesler, Soby, etc. Also limited edition in boards (bibl. 51).

Selected Bibliography

66. EDWARDS, HUGH. *Surrealism & Its Affinities*. The Mary Reynolds Collection. A bibliography compiled by Hugh Edwards. Chicago, Art Institute of Chicago, 1956.

A survey collection, including scarce and limited editions. Preface by Marcel Duchamp. For references to Duchamp see p. 126, p. 131 (index). Edition may be revised shortly.

67. GRESHMAN, HERBERT S. *A Bibliography of the Surrealist Revolution in France*. Ann Arbor, University of Michigan Press, 1969.

Largely books and articles, selected periodicals, selective collective tracts and manifestoes. Duchamp, pp. 16–17.

68. KARPEL, BERNARD. "Did Dada Die? A Critical Bibliography." In *The Dada Painters and Poets*, pp. 318–382. New York, Wittenborn, Schultz, 1951 (reprinted 1967).

A pioneer and major exposition, with annotations and index. Occasionally rearranged alphabetically and published without acknowledgment. No revisions of original documentation in latest re-edition. Duchamp references, p. 384 (index).

69. **LEBEL, ROBERT.** "Bibliography." In his *Marcel Duchamp*, pp. 177–188, 196–201. New York, Grossman Publishers, 1967.

A definitive exposition which includes addenda to the 1959 edition. Relevant data also interspersed in the catalogue raisonné, p. 154 ff. See bibl. 37 for other editions.

70. **POUPARD-LIEUSSOU, YVES.** *Bibliographie.* In *Marcel Duchamp, Marchand du Sel*, pp. 201–230. Paris, Le Terrain Vague, 1958.

A comprehensive and annotated record by the vice-president and bibliographer of L'Association Internationale pour Étude de Dada et du Surréalisme (Paris).

71. **SCHWARZ, ARTURO.** Elements of a descriptive bibliography of Marcel Duchamp's writings, lectures, translations, and interviews. In *The Almost Complete Works of Marcel Duchamp at the Tate Gallery*, pp. 92–109. London, Arts Council of Great Britain, 1966.

Extensive annotated record includes "written and spoken items by and not on the artist" (188 numbers, 1914–1966).

72. **SCHWARZ, ARTURO.** Elements of a descriptive bibliography of Duchamp's writings, lectures, translations, and interviews. In *The Complete Works of Marcel Duchamp*. New York, Abrams, 1969. pp. 583–617 incl. illus.

Includes 263 items "by" Duchamp; 294 references of "works quoted."

Index